IMAGES
of America

DETROIT'S MOUNT ELLIOTT CEMETERY

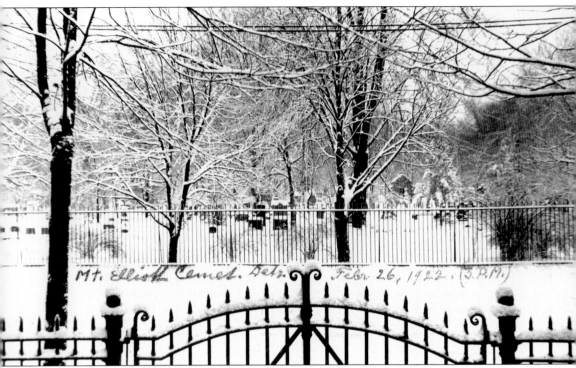

This photograph of the snow-covered cemetery, taken on February 26, 1922, at 3:00 p.m., is from the archives of St. Bonaventure Monastery, located across the street from the cemetery. The photographer was not recorded, but the time and date of the exposure were written on the print. (St. Bonaventure Monastery Archives.)

On the cover: The gates of Mount Elliott Cemetery are a landmark for Detroiters. The stone gateway was completed in September 1882. The cemetery is located on Mount Elliott Avenue and is bordered by Lafayette Street on the south, Vernor Highway on the north, and Elmwood Cemetery on the west. (Detroit Public Library, Burton Historical Collection.)

IMAGES
of America

DETROIT'S
MOUNT ELLIOTT
CEMETERY

Cecile Wendt Jensen

ARCADIA
PUBLISHING

Published by Arcadia Publishing
Charleston SC, Chicago IL, Portsmouth NH, San Francisco CA

Printed in the United States of America

Library of Congress Catalog Card Number: 2006925653

For all general information contact Arcadia Publishing at:
Telephone 843-853-2070
Fax 843-853-0044
E-mail sales@arcadiapublishing.com
For customer service and orders:
Toll-Free 1-888-313-2665

Visit us on the Internet at www.arcadiapublishing.com

In honor of my great-grandfather Piotr Wojtkowiak (1863–1897), who was born in Tulce, Sroda, Poznan, and died in Detroit, Wayne County, Michigan. In remembrance of all the souls buried in Mount Elliott's single graves without markers or monuments.

CONTENTS

ACKNOWLEDGMENTS

I would like to thank my husband James Jensen for his interest and help in this project. We were able to attend the Firemen's Fund Memorial Day ceremony, which was personalized with the annual participation of cousin L. Dino DiNatale, a retired Detroit Fire Department chief. I appreciate the welcome and hospitality of the Mount Elliott Cemetery Association (MECA), especially Russell Burns and Kari Wood. Kari has become a colleague in he research and editing of the book and Russ passed on stories and experiences of past directors of the cemetery.

The following archives were generous in the use of images and information for the publication: Detroit Firemen's Fund Association (DFFA); *Detroit Firefighter 1865–2005* author Cheryl Stathman (CS); Detroit News Collection of Walter P. Reuther Library, Wayne State University (DNC/WRL); Detroit Public Library, Burton Historical Collection (DPL/BHC) Archives of the Felician Sisters, Presentation of the Blessed Virgin Mary Province, Livonia, Michigan (AFSLM); Italian Study Group of Troy and Rose Vettraino, historian; Daughters of Charity Archives, Mater Dei Provincialate, Evansville, Indiana; Genealogical Society of Flemish Americans (GSFA); Bill Nichols, owner of Otto Schemansky and Sons Monument Company (BN); St. Bonaventure Monastery Archives (SBMA); *Mount Elliott Cemetery: A History* by Fern Freeman; *Mount Elliott Polish Burials* author James Tye; Wayne State University Library System (WSULS); and Archives of Michigan (AM). I also admire the work of Silas Farmer (SF), historiographer, who made my job so much easier.

Local family historians also contributed images and family stories for inclusion. All photographs from contributors are indicated with their initials after the caption, otherwise they were taken by the author: Sue Kramer (SK), Joseph Martin, Raymond McConnell (RM), Delores Hausch, Elizabeth Kelley Kerstens, Kathleen Labudie Szakall, and Sr. Joyce Van de Vyver (SJVV). I counted on my Polish Genealogical Society of Michigan colleagues J. William Gorski, Betty and Joe Guzak, Kenneth A. Merique, and James Tye for encouragement, suggestions, and editing. Don Harvey provided information on Civil War soldiers buried at the cemetery. I extend a heartfelt thank-you to all who shared family photographs, stories, and interest in the making of *Detroit's Mount Elliott Cemetery*.

INTRODUCTION

Mount Elliott Cemetery is Detroit's oldest extant cemetery started by the Catholic community in 1841 for the need and benefit of Detroit's Catholics. It was the first Catholic cemetery to be developed by what is now the Mount Elliott Cemetery Association.

Mount Elliott Cemetery was the fourth Catholic cemetery to be consecrated in Detroit. The Catholic Church specifies three requirements for a burial: the bringing of the body to the parish church, the funeral service in the church, and the burying of the body in a place legitimately designed for the burial of the faithfully departed. A supplement called "Catholic Cemeteries of the Archdiocese of Detroit" in the Michigan Catholic newspaper stated that Catholic cemeteries are called God's acre and exist not as a business proposition or a public burial park but as a consecrated place set aside for the burial of the faithful.

Catholic cemeteries also conduct themselves with respect for the state requirements. They are responsible for the registration of internments, regulations pertaining to public health and safety, laws relating to the location of cemeteries, prudent investment of perpetual care funds, and all matters relating to public welfare.

The first Catholic burial ground in Detroit was the church yard of Ste. Anne de Detroit, established to serve the French settlers and originally located on what was called St. Anne's Street in what is today about the center of present Jefferson Avenue between Griswold and Shelby Streets. Records show the first burial was Fr. Nicolas Bernadine Constantine Delhelle, killed by an Ottawa Indian in the summer of 1706. The original cemetery was used for a century until the fire of 1805 destroyed the church and much of Detroit. At that time, the U.S. government decided to lay out the city on a new plan that, while practical, removed most of what could be recognized as the old French city. Jefferson Avenue replaced St. Anne's Street and the parish was given land on Larned Street upon which to build the new church and cemetery. Despite careful planning and lots of space, the new cemetery was only in use for 10 years until it was filled with graves.

In 1827, Antoine Beaubien sold two and a half acres to the city for additional burial grounds. The city divided the grounds into two equal parts for a Catholic and Protestant cemetery. This newest Catholic cemetery was blessed but was not named. The expanding population and the cholera epidemics of 1832 and 1834 filled the new cemetery on St. Antoine Street sooner than expected.

In the 1830s, the Catholic population of Detroit was made up of more than just French immigrants. Irish and German immigrants were building their own churches (Holy Trinity and St. Mary, respectively) and wishing to have their own burial grounds. This desire led the parishioners of Holy Trinity to purchase ground for a new cemetery. The Leib farm was selected and the purchase of 12 acres on what is now Mount Elliott Avenue was made. On August 31, 1841,

Fr. Martin Kundig and his church committee titled the property: "To the Right Rev. Frederick Rese, Roman Catholic Bishop of Detroit, and his successors in the office of bishop, forever, in trust for the exclusive use and benefit of the Irish Roman Catholic congregation of Trinity Church."

Twelve days after the purchase was complete, Robert T. Elliott, a noted architect in Detroit and one of the original committee members from Holy Trinity responsible for the creation of the cemetery, was killed in a construction accident at St. Mary's church. He was laid to rest in the new cemetery and it was named in his honor—Mount Elliott Cemetery.

When the city authorities prohibited any additional burials at the Protestant and Catholic cemeteries on St. Antoine Street in 1855, the French Catholics began burying their dead at what they referred to as the "Irish Cemetery."

On November 5, 1865, the cemetery was incorporated and placed in the care of 12 trustees. Each of the six participating parishes elected two trustees. The first six parishes were SS. Peter and Paul, Ste. Anne de Detroit, St. Mary, Holy Trinity, St. Joseph, and St. Patrick, and the original trustees were: Richard R. Elliott and P. McTerney of SS. Peter and Paul (Irish), Charles Peltier and Francis Mailloux of Ste. Anne de Detroit (French), Frederick Gies and A. H. Schmittdiel of St. Mary (German), William Buchanan and John Mulroy of Holy Trinity (Irish), A. Lingermann and John Schulte of St. Joseph (German), and John Heffron and Patrick Black of St. Patrick (Irish). Frederick Gies and Patrick Blake were also undertakers. The "Report of the Trustees of Mount Elliott Cemetery stated that the property comprised eleven acres known as Mount Elliott Cemetery and sixteen adjoining acres." The report continues, "having placed the cemetery in charge of the sexton, established a concise system of registry for all interments, and stringent rules for enforcing order and respect due to the concentrated grounds of a Catholic cemetery, the Trustees proceeded to open out and improve the new grounds and to place the lots on sale." The new grounds were formally dedicated by Bishop Peter Paul Lefevre on December 7, 1865.

On April 21, 1869, a special committee was appointed to negotiate with the city for the sale of grounds and reinterment of bodies removed from the Catholic portion of the old city cemetery on St. Antoine Street. Bishop Lefevre began negotiations for the transfer of remains before his death. The committee received the remains of 1,490 bodies enclosed in 113 boxes of which 13 were interred in private lots and 100 in lots in section I. The city paid for lots 53, 54, 57, 58 and 72–77 in section I at Mount Elliott Cemetery. The committee received $592.50 from the City of Detroit for this transaction.

Silas Farmer chronicled Mount Elliott in his 1890 *History of Detroit and Wayne County and Early Michigan: A Chronological Cyclopedia of the Past and Present*: "The committee purchased the Leib Farm, and was bounded by Waterloo Street on the north, Macomb Street on the south, Mount Elliott Avenue on the east, and Elmwood Cemetery on the west. In 1882 it contained sixty-five acres. The first purchase of eleven acres was made on August 31, 1841. The cemetery is named after Robert T. Elliott, one of the original projectors and purchasers. His own interment, the first in the grounds, took place on September 12, 1841. From that day to January, 1884, the aggregate of interments reached about 25,765, not including the remains of 1,490 graves removed from the old City Cemetery on the Beaubien Farm in the fall of 1869. The ground was laid out into about 6,000 lots, of which upwards of 4,000 have been sold at prices ranging from $25 to $300. Single graves were sold at a fixed price and the poor are buried free."

Chapter One includes photographs of tombstones and monuments of many former trustees of the Mount Elliott Cemetery Association representing the different nationalities of the Catholic community: R. R. Elliott, Joseph B. Moore, A. E. Viger, Francis Petz, A. Petz, C. J. O'Flynn, Jeremiah Calnon, John Heffron, and Joseph Schultz. Throughout the years sons have followed in their father's role as sextons, directors, general managers, and trustees of the organization.

The current director of Mount Elliott Cemetery, Russell Burns, and his father, Raymond James Burns, have contributed many years of service to the association. They can trace their family back to Patrick Burns who was the first sexton of Mount Elliott Cemetery. Raymond James Burns (retired manager, general manager, and trustee) is the son of Raymond John Burns, who was the son of William J. Burns, who was the son of Patrick Burns (sexton), who was the

son of P. Burns who is believed to have been on the committee that formed the cemetery and placed the first fence around it.

The records of Mount Elliott cemetery are of interest to a wide range of researchers including historians, genealogists, and those interested in graveyard studies. Silas Farmer, Detroit City historiographer, wrote in the preface to the 1886 *History and Rules of Mount Elliott Cemetery* that "hundreds of families in Detroit have no evidence as to where their parents or grandparents are buried, and many who are interested in genealogical research (and ought to be) would pay large sums of money to know where their ancestors lie. The present generation should remedy this evil as far as possible, and those who follow should have such a record as can now be obtained and preserved."

Fern Freeman compiled the *Mount Elliott Cemetery: A History* booklet for a Detroit Historical Museum walking tour on July 12, 1981. Her research makes reference to the Burton Historical Collection and her obituary extractions are used extensively throughout the book.

The earliest records of the cemetery were destroyed in an office fire about 1865. Genealogist Mary Lou Duncan sought to recreate the records and first published *Mount Elliott Cemetery Burial Records 1845–1861* in 1994 with a second printing in 1999. Her work was published by the Detroit Society for Genealogical Research, Inc. Duncan accessed records held by the Archdiocese of Detroit and the Burton Historical Collection of the Detroit Public Library. The 74 page softbound book begins with simple entries of the name of the deceased, date of interment, grave location, and cost of the grave. As the years progressed additional information such as age and cause of death were recorded. The plot sales lists and the burial records of 1845–1847 are held by the Archdiocese of Detroit. The burial lists for 1854–1861 are held in three locations the Detroit City Archives, city clerk's records, and at the cemeteries. These were weekly or monthly reports of deaths submitted to the city by the sexton.

Duncan advises researchers to use the list as a guide. She suggests that researchers access the parish records and, in the case of St. Mary's, additional information can be gained including full given name and town of birth. The early registers have been microfilmed and can be accessed at the Burton Historical Collection after signing a consent form.

Duncan has recorded the early sextons of Mount Elliott Cemetery and lists the following as having submitted reports of burials: John Conehan, 1854–1855; Thomas Mathews, superintendent, December 1855; Richard Bourke, sacristan, August 1858–May 1860; and Patrick Devlin, July 1860–July 1861. The burials for this time period were predominately of Irish, French, and German heritage.

Many of the deaths in the 19th century were attributed to smallpox, diphtheria, whooping cough, cholera, and dysentery, which are diseases that are today controlled by inoculations and antibiotics. Archaic medical terms include ague, summer complaint, consumption, and travail. Seasonal deaths included the August 1858 demise of William Quigley (45 years old) of sun stroke and Anne Murray's death in February 1860 (67 years old) from the effects of the cold. Occupational deaths of workers were also recorded: Shannon Thomas, 17, killed on the Central Railroad, October 1854; Jerry Finn killed in the Michigan Central Depot; Jacob Flemming killed by Canadian Central Railroad cars; Daniel Heger killed in June 1855 by a team of horses as was James Devine October 1855.

The records from 1866–1895 were evaluated and extracted by genealogist James J. Tye. His focus was the Polish burials of this time period. Tye spent several years researching the records on microfilm and in the books in the office of the cemetery. He accessed the Mount Elliott general index 1865–1932 microfilmed by the Church of Latter Day Saints (catalogued as film number 2080212). He also extracted the names of individuals listed in the records of four Polish churches: St. Albertus, St. Francis d'Assisi, St. Casimir, and St. Josephat. He also obtained records of the deceased interred at Mount Elliott Cemetery with Polish surnames from other Catholic churches in Detroit. He employed his keen knowledge of Detroit's Polonia to extract surnames that are not immediately recognized as Polish surnames. Many Poles from German Poland bore German variations. He created the alphabetical list of 5,727 names to serve as a

substitute index and record of deaths of the pioneers of Detroit's Polonia due to the absence of early Polish registers of death. His hope is that the manuscript will aid family historians in their collective research of the Polish ancestors who lived in the city of Detroit. His manuscript was self published in 2001.

The monuments and tombstones at Mount Elliott are a beautiful collection of mortuary artwork covering the 19th and 20th centuries. The tombstones at Mount Elliott reflect family names well know in the tri-county area: Beaubien, Campau, Caniff, Chene, Cicotte, Moross, and Moran. These religious, business, and political leaders have left their names on buildings, roads, and landmarks. The private mausoleums display influences from Classical, Romanesque, even Egyptian architecture. Mount Elliott has examples of each influence, especially the classical. Modeled after Greek and Roman temples, with their many columns, pediments, and strong symmetry, buildings in the classical style were very popular throughout the 1800s.

William (Bill) Nichols is the current owner of Otto Schemansky and Sons Monuments. He is part of a family that has Detroit history as monument makers. Nichols's father owned additional monument companies. When he purchased Schemansky and Sons the sale included the order books beginning in 1900. The books are intriguing. They not only show pencil sketches of the ordered monument or tombstone but also contain margin notes of when the family member wanted the monument in place or if they wanted to be present. Their home address is usually listed. Schemansky did quality work and he was the creator of the marble monument of Father Doherty, the Hamtramck ledger order in 1949, and the monument for Fr. J. Dombrowski ordered by the Felician Sisters.

One of the first symbols of Catholic burial is the cross. There are a range of crosses and inscriptions at Mount Elliott. The Greek cross looks like a plus sign, the Latin cross looks like a *T*, and the Celtic cross has a circle (nimbus) connecting the four arms of the cross. All three types are represented at Mount Elliott in multiple variations.

Many things have changed over the last 165 years, but Mount Elliott Cemetery will always be the final resting place of the immigrants who settled and built Detroit out of the wilderness along the river. Mount Elliott is the beginning of the legacy of the Mount Elliott Cemetery Association. Mount Elliott is home to the early French, Irish, German, Belgian, and Polish residents of metro Detroit, but later cemeteries developed by the association are solid examples of 20th century burial practices and cemetery design. The Mount Elliott Cemetery Association provides perpetual care for Mount Elliott Cemetery and its four sister cemeteries: Mount Olivet, Resurrection, All Saints, and Guardian Angel.

Mount Elliott has only private mausoleums and a small chapel, but the newer cemeteries in the Mount Elliott Cemetery Association have features never imagined by the first trustees. Guardian Angel in Rochester has marble faced crypts and niches for burial and remains in a temperature controlled mausoleum and columbarium. It is complete with skylights, music, carpeting, and upholstered seating. The Prince of Peace Crematorium, located on the grounds of Resurrection Cemetery and serving all association cemeteries, offers an option only recently allowed by the Catholic Church. All Saints Cemetery in Waterford is situated on the picturesque banks of Lake Maceday.

The cemeteries span three centuries and offer Catholic customs and stability in a time of restless mobility. As it enters its third century of service, the Mount Elliott Cemetery Association will continue to be "Keepers of Family Tradition."

One

THE MOUNT ELLIOTT CEMETERY ASSOCIATION

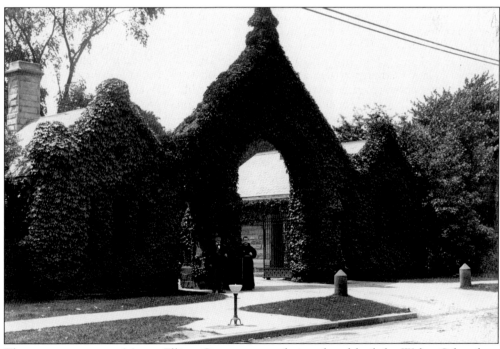

The stone gateway to Mount Elliott Cemetery was designed and built by Walter Schweikart and was completed in September 1882 at the cost of $6,000. Schweikart also designed and built the stone arched entrance for Elmwood Cemetery. Standing with the sexton is Fr. Crescentian Voelpel. (SBMA.)

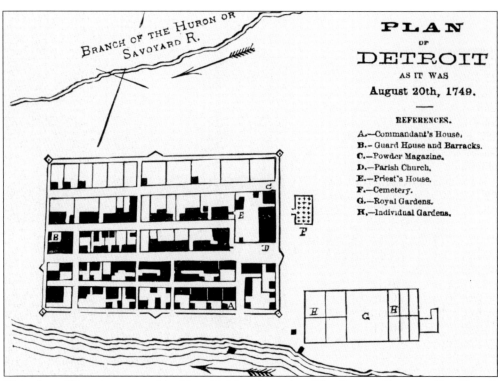

This plan of Detroit, engraved by Detroit's historiographer Silas Farmer, illustrates Fort Detroit in August 1749. The flows of the Detroit and Savoyard Rivers are indicated by arrows. The royal and individual gardens are located outside the fort's walls. The cemetery, labeled *F*, is located outside the fort near the powder magazine, priest's house, and the parish church. (SF.)

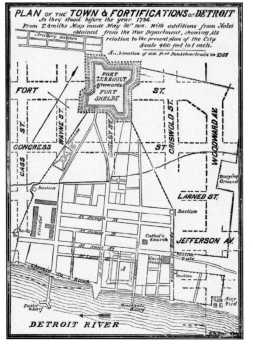

Silas Farmer's engraving of T. Smith's 1816 map document's the plan of the town and fortifications of Detroit around 1796. Fort Lernoult, eventually Fort Shelby, is shown at the intersection of Fort and Shelby Streets. The magazine is located near Congress Street and the citadel is bordered on the south by St. Anne's Street. The Catholic church is near the corner of St. Anne's Street and Campau Alley. The cemetery is labeled as burying ground east of Woodward Avenue bordered on the north by Congress Street and Jefferson Avenue on the south. (SF.)

Joseph Campau, who was born on February 20, 1769, and died July 23, 1863, was buried with his wife, Adelaide Dequindre Campau, in Elmwood Cemetery, in section W, lot 4. He was excommunicated in 1817 and could not be buried in Mount Elliott Cemetery. Some of his children are buried at a family plot and monument in section 19, lots 145 and 146. He owned 10 stores in Michigan and invested store profits in real estate. At the time of his death, he owned $10 million in land, making him the largest landowner in Michigan. After his marriage to Adelaide Dequindre in Ste. Anne de Detroit in 1808, Campau had many disagreements with Ste. Anne de Detroit's Fr. Gabriel Richard, not only over his membership with the Masons but also because he sold whiskey to the Native Americans. He had 10 children. (DPL/BHC.)

The University of Michigan–Dearborn Pluralism Project states that Holy Trinity, founded in 1834, was the first English-language Roman Catholic parish in Detroit. The earliest parishioners of the church were Irish immigrants who had settled in the area but had attended nearby Ste. Anne de Detroit, the city's French-language parish. Fr. Bernard O'Cavanaugh, the first Irish priest at the parish, was assigned to Holy Trinity in 1835. The neighborhood surrounding Holy Trinity is known as Corktown named for the county in Ireland from which many of Detroit's Irish immigrants came. Today the parish is known as Most Holy Trinity. (SF.)

The ledger entries of lot owners, shown at right, include the families of the following: Peter Graham, Daniel Burns, Mrs. David Welch (who purchased an entire lot), Thomas Coleman, A. Quinn, and Mrs. F. O'Connor. The left column is titled "poor ground." The penmanship is difficult to read, despite the story that all clerks at the office were required to take a handwriting test before being hired. (MECA.)

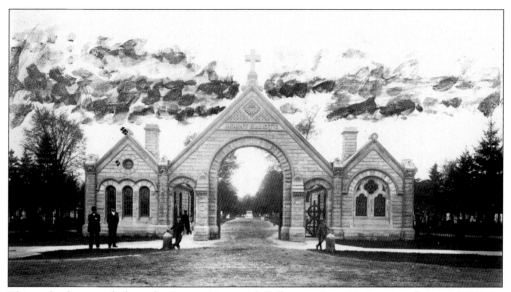

This early photograph from the Burton Historical Collection shows the gates without ivy. The sky has been enhanced with the photographer's retouching paint. This undated image also shows Mount Elliott Cemetery with an unpaved road. The base of the Daniel Campau monument can be seen beyond the gates. One of the men photographed at the left is most likely the sexton. (DPL/BHC.)

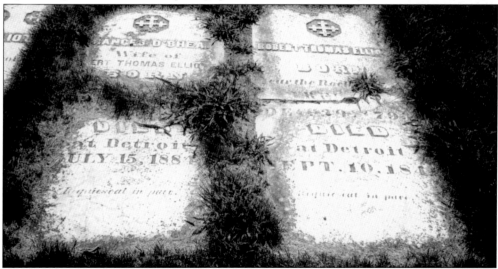

Shown here are Mount Elliott Cemetery ledgers for Robert T. Elliott, who was born December 20, 1795, and died September 10, 1841, and his wife, Frances, in section 71, lot 509. Elliott arrived in Detroit in 1834 and was probably Detroit's first educated architect. In 1835, he designed and completed the remodeling of the First Protestant church, which was later purchased by the Irish Catholics and renamed Trinity Church. Located on the northwest corner of Cadillac Square and Bates Street, Trinity was the first English-speaking Catholic church in the western states. In 1840, Elliott was elected associate judge of the Wayne Circuit Court. He was one of the original committee members who purchased the land for Mount Elliott Cemetery. In 1841, he died in a construction accident at St. Mary's church, a project he was directing. He was the first interment in Mount Elliott Cemetery, and it was named for him. His children are also buried at Mount Elliott Cemetery.

St. Mary's parish was founded in 1834 by Fr. Martin Kundig to accommodate the spiritual needs of the German-speaking Catholics. It is the third-oldest parish in the city. Early in 1841, Antoine and Monique Beaubien sold the land at St. Antoine Street and Croghan Street (now Monroe Street) to be used as the site of the new St. Mary's church. The tower's four bells were donated by Antoine Beaubien and Monique. (SF.)

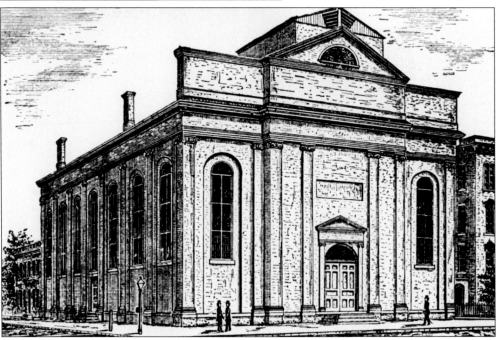

Ste. Anne de Detroit was designated as the cathedral church of the entire Northwest Territory until it was replaced by a new Detroit church, SS. Peter and Paul Jesuit Church, shown above. The cornerstone of SS. Peter and Paul church is dated June 29, 1844, making it the oldest church building in the city of Detroit. It was completed and consecrated as Detroit's Catholic cathedral on June 29, 1848. The builder of the church was Bishop Peter Paul Lefevre. (SF.)

Ste. Anne de Detroit is the second-oldest continuously operating parish in the United States (after St. Augustine in Florida) and has occupied many buildings. The oldest-surviving church records begin with the baptism of Marie Therese, born to Antoine de la Mothe Sieur de Cadillac and his wife Marie Therese Guyon on February 2, 1704. Fr. Gabriel Richard arrived at Ste. Anne de Detroit in 1796. He helped start the school there that eventually evolved into the University of Michigan. (SF.)

St. Joseph parish began in 1855, when the Reverend Edward Franz van Campenhout, an assistant at St. Mary's parish (located in today's Greektown neighborhood), left that church to found a new German parish. The parish's first recorded function, a baptism, took place in January 1856. In 1863, the Reverend Johann Ferdinand Friedland was assigned to St. Joseph parish. Born in Germany, he was educated at Louvain, Belgium, for the missions in America. (SF.)

CALVARY AVENUE

This map shows the early names given to the roads in the cemetery. One road is named for Fr. Martin Kundig. When a cholera epidemic broke out in the city, the Catholic Female Association, organized by Father Kundig, assumed the burdens of nursing the sick, burying the dead, and caring for the orphans. Father Kundig's medical skill, administrative ability, and compassion were recognized in 1834, when the county board of supervisors appointed him as superintendent of the poor. (MECA.)

The rules and regulations booklet set specifications for tombstones, monuments, and inscriptions. Only Christian symbolism was to be displayed. The 1886 book explained this rule: "So many gross errors have been made in inscriptions, legions, or quotations placed upon fine monuments and stone erected in the cemetery, that the Trustees respectfully direct attention to regulations governing the same. This refers to stones having more than the names, nativity, dates and family record of the deceased; of course all such when properly written are unobjectionable. The errors referred to occur in more lengthy inscriptions, some of which from their absurdity create derision rather than sympathy or respect. Hereafter a copy of all inscriptions intended for tombstones or monuments, in English, French, German, Latin, or Greek, must be submitted to the superintendent, who will have them examined, approved, or corrected." (MECA.)

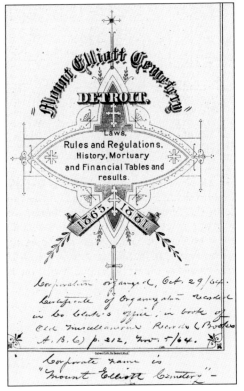

19

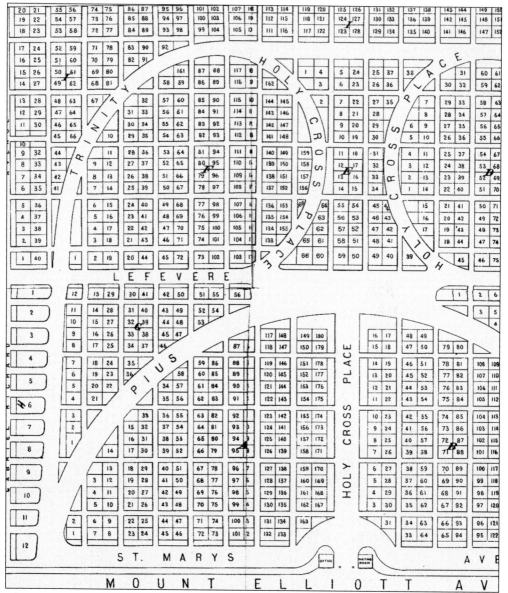

This section of the map shows the road dedicated to Bishop Peter Paul Lefevre. He was born on April 30, 1804, at Roulers, Belgium, and immigrated to the United States in 1828. He established many parochial schools and brought in the Christian Brothers, the Sisters of Notre Dame, the Sisters of Charity, and the Sisters of the Immaculate Heart of Mary. He died on March 4, 1869, and was buried at SS. Peter and Paul church. (MECA.)

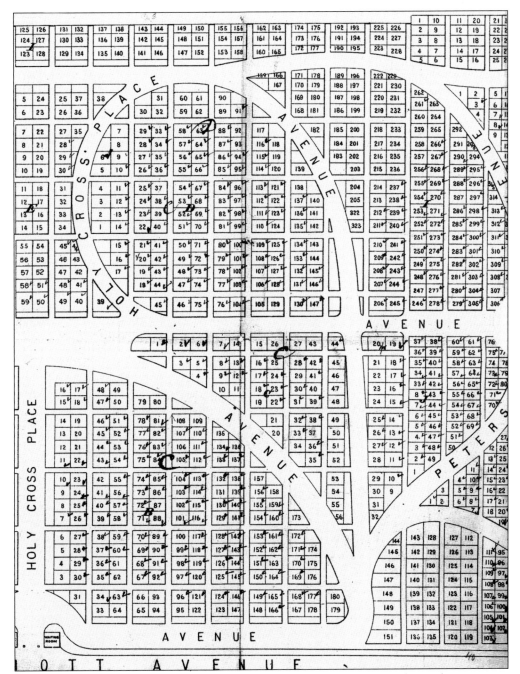

The unmarked road, seen here above Holy Cross Place and running along the single graves, was dedicated to the memory of the Reverend M. E. E. Shawe, an English noble, soldier, and pastor of the Cathedral of SS. Peter and Paul (ordained in France). Reverend Shawe was fatally injured while traveling to the consecration of the Assumption Church and died on May 10, 1853. A memorial was placed in Assumption Grotto by Frances Elliott to remember the priest. (MECA.)

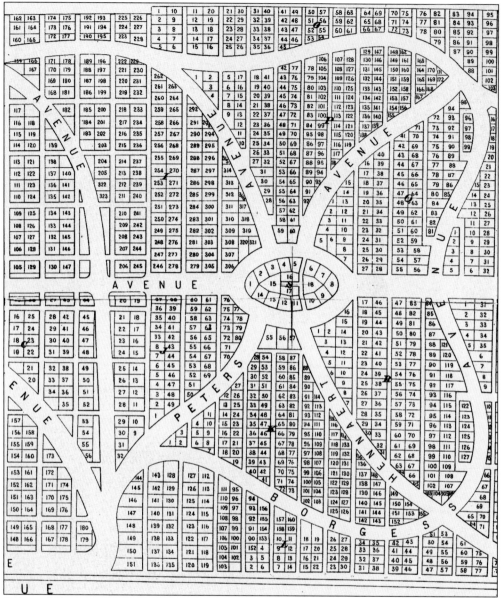

Bishop Casper H. Borgess was honored with a road in the cemetery. Bishop Borgess was appointed as the successor to Bishop Federick Rese, consecrated as the bishop of Calyson, and made coadjutor and administrator of Detroit on April 24, 1870. On the death of Bishop Federick Rese, December 30, 1871, Bishop Borgess assumed the title of bishop of Detroit. He resigned April 16, 1888, and died May 3, 1890. (MECA.)

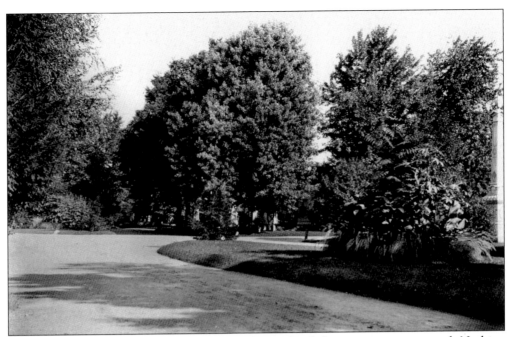

This undated photograph was taken before the roads of the cemetery were paved. Nothing remains dormant in the life of a cemetery; throughout the course of its history, roads in Mount Elliott Cemetery have been redirected, closed, and renamed. Victorian appointments such as iron benches and fences have been removed as they deteriorated and styles changed. (MECA.)

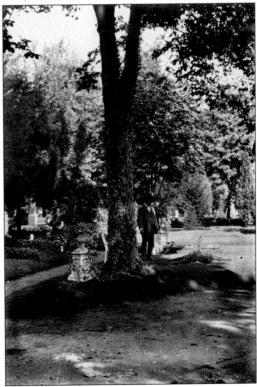

The sexton is surrounded by Victorian-style landscaping. Ivy not only flows from an urn on a pedestal but also has grown up the trunk of the tree. Two graves on the left of the photograph are also covered with ivy. A good ground cover, ivy is mentioned in Keister's book on symbolism as being symbolic of immortality and fidelity; its three-pointed leaves also make it a symbol of the Trinity. (MECA.)

During the late 1800s, Mount Elliott Cemetery had the look of a magnificent Victorian garden cemetery and arboretum. Today it is splendidly forested with arborvitae, green and white ash, three types of beech, a white birch, catalpa, eastern red cedar, cherry, crab apple, Douglas fir, elm, ginkgo, honey locus, horse chestnut, juniper, linden, magnolia, as well as Japanese, Norway, red, sugar, and silver maple trees. The fall foliage is enhanced by the contrast of the oak, pine sassafras, sweet gum, and yew trees. (MECA.)

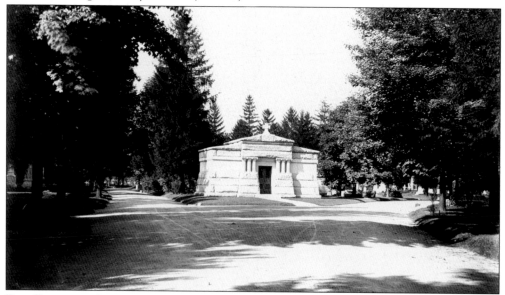

Even Egyptian architecture is represented in the cemetery, as the completion of the Washington Monument in 1884 (an Egyptian obelisk) renewed interest in this style. The obelisk is the most common example in Mount Elliott Cemetery, but battered walls (thick at the base with an incline toward the top) are used in the receiving vault, which was converted into a chapel. (MECA.)

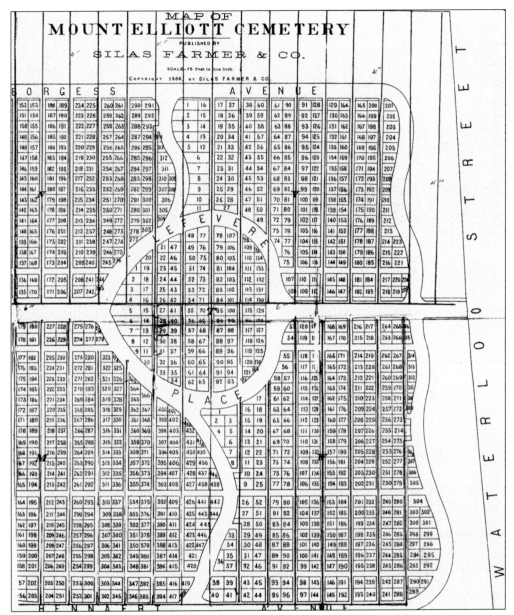

This is the newest portion of the cemetery. Director Russell M. Burns likes to point out to visitors that the cemetery reflects the immigration patterns of the city of Detroit. If one begins to walk the cemetery from the southern end near Lafayette Street, one sees French and Irish surnames. As one continues to walk, one starts to see German surnames. At this end of the cemetery, Polish names are more prevalent. (MECA.)

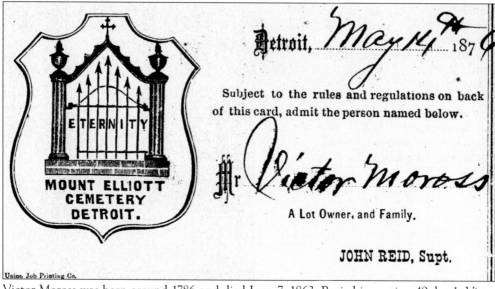

Victor Moross was born around 1786 and died June 7, 1863. Buried in section 49, lot 1, Victor was the father of Christopher Moross and owned a tavern on Jefferson Avenue that was always closed during high mass on Sundays. Fr. Gabriel Richard would frequently stop in at the tavern, urging Victor to stop selling whiskey. Victor, however, refused because the sales of whiskey were profitable. One night, a tornado struck, and the only damage done was to a great oak post with a mortised sign that read Victor Moross Tavern. Victor saw this as a sign from the Lord, and from that moment on, he never sold another drop of liquor at his tavern. (DPL/BHC.)

Extract from the Rules governing the Cemetery.

No children allowed in the grounds without parents or guardians; nor any horse unfastened or fastened to a tree; nor any dog. No smoking allowed. No person to touch any flowers (*wild or cultivated*) or to break or destroy any tree, plant or shrub, nor to injure, cut or deface any monument, gravestone or other structure, or any fence, or enclosure. No person to disturb the quiet and good order of the place; and all required to keep on the avenues, walks and alleys, and not trample on the grass. Heavy penalties are imposed for a violation of these rules.

Visitors are reminded that these grounds are consecrated for the interment of the dead, it is therefore indispensable that there should be a strict observance of all the proprieties due to the place.

JOHN REID, Superintendent.

DO NOT LEND OR TRANSFER THIS CARD.

Mamie Moross Oakman was one of the 16 children of Rose Ann Beaubien and Joseph A. Moross, who built the Moross homestead. Joseph Moross, who died April 16, 1890, and was buried in section B, lot 109, built the route that circled the city (now known as Grand Boulevard). Mamie Moross married Robert Oakman, the planner and builder of Ford Avenue, which was later renamed Oakman Boulevard. (DPL/BHC.)

John Valee Moran was born December 25, 1856; died November 15, 1920; and was buried in section 59, lot 1028. Moran was the son of Judge Charles Moran III. After attending a commercial college, he was hired in 1876 by the wholesale grocery house of Moses W. Field and Company, where he was a clerk for 15 months. He left to become assistant bookkeeper with John Stephens and Company and 18 months later was hired as a shipping clerk with Beatty and Fitzsimmons, another wholesale grocery house. After Beatty's death in 1885, the company became Moran, Fitzsimmons, and Company. He served as secretary and director of Ward's Detroit and Lake Superior line of steamers, a director of People's Savings Bank, and vice president of American Banking and Savings Association. With his wife Emma, he had the following children: Valorie, Justine, Etheridge, Bell, Granville, Stephanie, Lyster, Alise, and Cyril. (SF.)

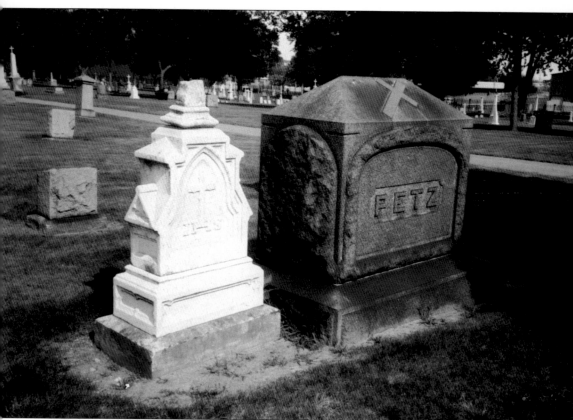

Francis Petz was born June 18, 1832; died March 29, 1897; and was buried in section 76, lot 536. In 1858, Francis was in the jewelry business at 95 Gratiot Avenue. His brother Joseph Petz joined the business 10 years later, and the store was moved to 22 Monroe Street. Joseph died in 1883, and in 1892, Francis sold the store because of his poor health. Francis was a trustee and, for more than 15 years, the treasurer of Mount Elliott Cemetery. He and his wife Caroline Lingermann Petz had children, including Francis X., Anthony J., Theresa, and Catherine Schulte.

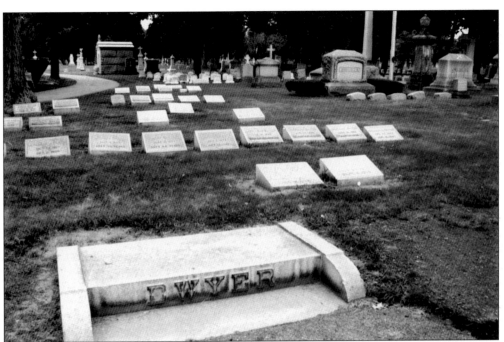

Jeremiah Dwyer was born August 22, 1838; died January 29, 1920; and was buried in section E, lot 60. Jeremiah learned the molders trade, and his brother James became a machinist and eventually the president of the Mount Elliott Cemetery Association. In 1861, the brothers created J. Dwyer and Company, stove founders. In 1864, the company was reorganized and became Detroit Stove Works. In 1871, when Jeremiah founded Michigan Stove Company, it was the largest stove manufacturing plant in the world. On November 22, 1859, he married Mary Long. Their children were James W., Elizabeth, John M., William A., Francis T., Vincent R., Emmet, and Gratton L. (SF.)

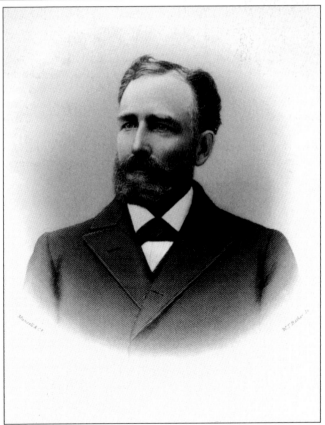

Daniel J. Crowley was born June 14, 1902; died February 10, 1957; and was buried in section L, lots 145 and 146. Daniel J. was the son of Joseph J. Crowley and a grandson of Cornelius Crowley. In 1901, Daniel J.'s father, Joseph, and his uncles, Daniel T. and William C., established Crowley Brothers Company, dealers in wholesale dry goods, notions, and furnishings. Joseph, considered the financial genius, also became vice president and treasurer of Crowley-Milner Company, a large retail dry goods house, in 1914. Three years later, the Crowley-Milner Company was the largest store in Michigan. Joseph Crowley later became president and treasurer and also served as president of Mount Elliott and Mount Olivet Cemeteries. Daniel J. was vice president and board member of Crowley-Milner Company in 1927. He became president in 1938. He never married and lived with his mother until her death in 1956. Joseph is also buried in section L, along with fellow Crowley family members. (DNC/WRL.)

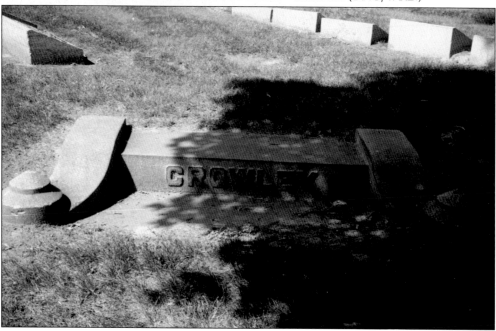

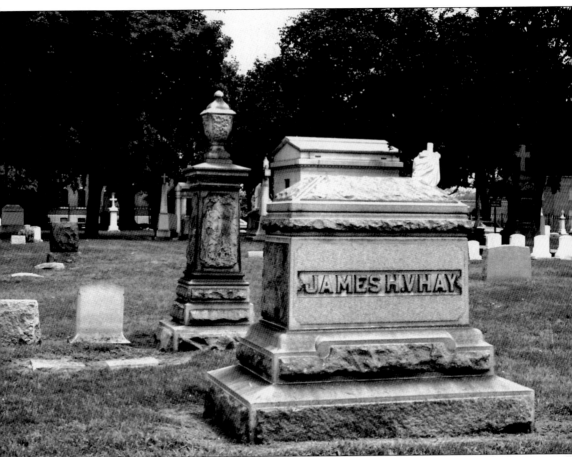

James H. Vhay was born in 1839; died June 26, 1895; and was buried in section B, lot 48. He came to Detroit in 1863 and was among the first to supply Detroit with year-round vegetables and fruits. He was a trustee of Mount Elliott Cemetery Association and director of the Detroit International Fair and Exposition. In 1866, he married Mary Farrell. Interred are the following family members: Harry, who died in 1887 at age 15; Eliza Farrell, who died in 1894 at age 51; Ann Farrell, who died in 1895 at age 77; Stella Vhay Richardson, who died in 1912 at age 31; and Anna E. Vhay, who died in 1944 at age 76.

The Arthur A. Schrage monument stands on lots in section E that were first used as the friars' burial ground. The surname Schrage has been associated with the Mount Elliott Cemetery Association for many years. Joseph A. Schrage Sr. and his son Joseph E. Schrage Jr. both served as general managers and trustees of the association. Relative Robert E. Schrage is the current director of Resurrection Cemetery in Clinton Township—the third cemetery established by the association.

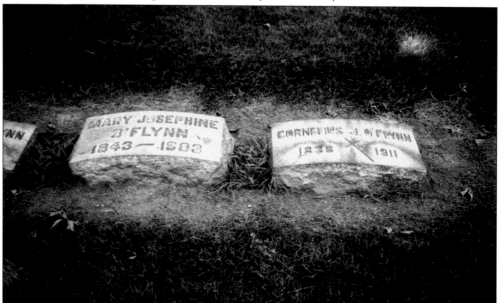

Cornelius J. O'Flynn was born in 1810; died January 27, 1869; and was buried in section D, lot 80. His oldest brother, John O'Flynn, was editor and publisher of the *Tralee Mercury*. Cornelius was a lawyer, serving as city attorney from 1840 to 1843. He authored the law of 1842, forming the foundation of the city school system, and served as probate judge for two terms. He was also a Mount Elliott Cemetery trustee. He loved and collected rare and expensive books. Cornelius and his wife Mary Josephine had the following children; John, Mary, Virginia, Emily, Louise, Irene, Cecilia, and Catherine.

Two

ERIN GO BRAGH

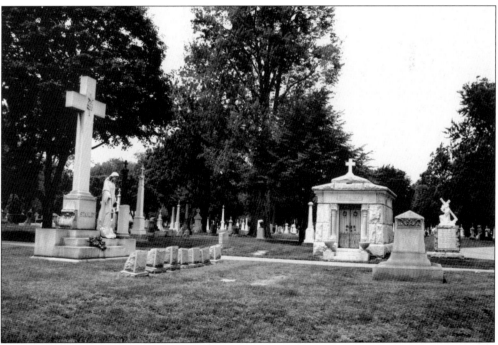

The mausoleum shown is that of Michael Sullivan, who was born March 18, 1849; died December 5, 1936; and was buried in section J, lot 30. Michael was the son of Jeremiah and Margaret Sullivan. He worked in the Great Lakes–dredging business for nearly 75 years. He formed Michael Sullivan Dredging Company, handling the channel of St. Mary's River and forming the trench and tube foundations for the Detroit-Windsor Tunnel. Michael and his wife Mary (Dufton) Sullivan had the following children: Dunbar, Fraser, Norbert M., Dufton J., and daughters Geneva and Margaret.

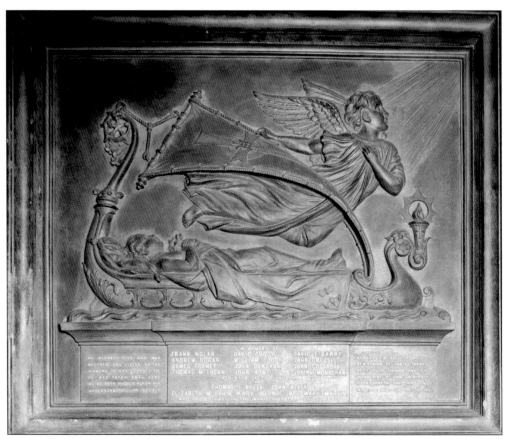

In March 1881, an elegant white bronze tablet was erected at Holy Trinity church at the cost of $375 in memory of the 17 acolytes and members of the church who perished in the *Mamie* disaster, which occurred on the Detroit River on July 22, 1880. The tablet was furnished by J. H. Eakins, founder of the Detroit Bronze Company. It reads, "In memory of Frank Nolan, Andrew Doran, James Toomey, Thomas McLogan, David Cuddy, William Cuddy, John Donovan, John Hoiw, David E. Barry, John Greusel, John Consgrove and John Monaghan acolytes of this church. Also remembered are Thomas E. Kelly, John Kelly, Elizabeth Murphy, Mary Horny and Mrs. Mary Martin, who passed away in the *Mamie* disaster." A priest who saved three altar boys, the Reverend A. F. Bleyenberg (1869–1883), pastor of Holy Trinity parish, is buried in the priest's lot in Mount Elliott.

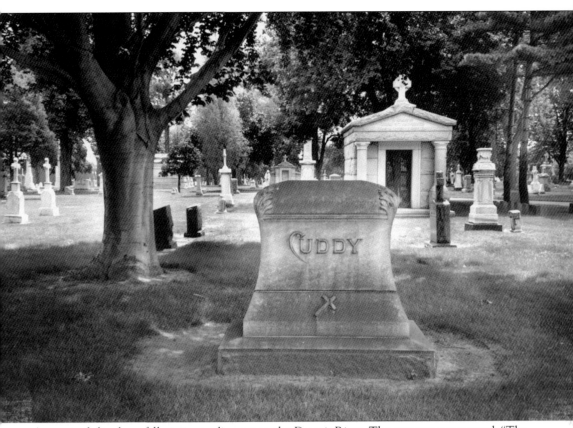

A group of altar boys fell victim to disaster on the Detroit River. The newspaper reported, "The new pleasure steamer *Garland* collided with the elegant steam yacht *Mamie*, just below Grassy Island Light on the Detroit River on July 22, 1880. The bow of the *Garland* struck the *Mamie* just behind the wheelhouse and rode right over its amidships. There was some delay in launching a lifeboat from the *Garland*, and, before it had cleared, the *Mamie* went down; of the 24 persons aboard, 17 were lost. On the *Mamie* was a party consisting of Reverend A. F. Bleyenberg, 16 lads (who acted as acolytes or altar boys for the church), and a few friends. The *Mamie* was returning to Detroit from a trip to Monroe. A large party of Detroit Stove Works employees was traveling on the *Garland* as well." Pictured here is the monument, in section A, lot 152, for the Cuddy family that lost David (1869–1880) and William (1866–1880) in the disaster.

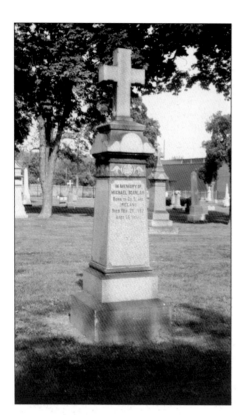

Michael Scanlan's tombstone follows the Irish tradition of indicating the deceased's county of birth. His tombstone reads, "In memory of Michael Scanlan, born in Co. Clare, Ireland died Feb. 28, 1882 aged 65 years."

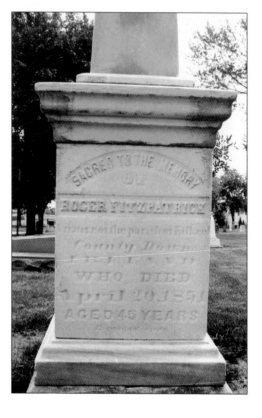

This tombstone is inscribed, "Sacred to the memory of Roger Fitzpatrick, a native of parish of Kilkee, County Down, Ireland, who died April 20, 1851, aged 45 years, requiescat in pace [may he rest in peace]." Also commemorated are infant children of Roger and Ann Fitzpatrick, Ann Eliza and Matilda (1846–1847). The photograph shows the base of the monument, which is supporting a tapered obelisk with a finial cross, which is located at section 16, lot 12.

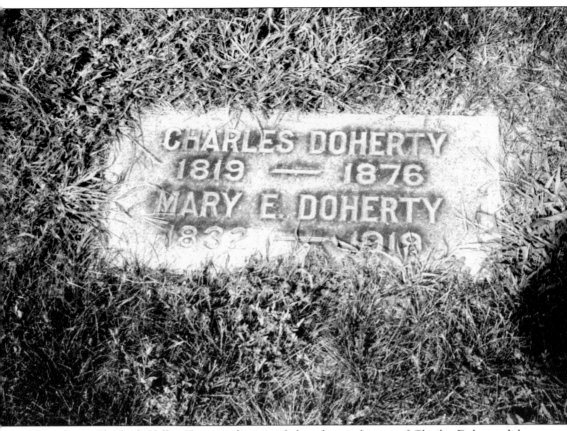

Genealogist Elizabeth Kelley Kerstens discovered that the tombstone of Charles Doherty did not adhere to the Irish tradition of listing the county of birth. The stone is in section H, lot 6. Starting with an 1858 baptismal record, she followed a path that wove through vital records, censuses, and city directories that indicated that Doherty served during the Civil War. She was able to document that Doherty, son of John Doherty and Margaret Lynch Doherty, was baptized April 3, 1818, in Caher Parish, County Tipperary.

James Flattery was born January 23, 1825; died November 18, 1897; and was entombed in a private mausoleum, prominently displaying his name. According to the city directories from 1855 to 1886, the Flattery brothers were Dennis, James, and Neil; Dennis died in 1875. The Flattery Brothers' furniture factory was at 12 St. Antoine Street, and they had a store at 26 Woodward Avenue. In 1869, they moved to 98 Woodward Avenue. The home of James Flattery was at 384 Jefferson Avenue and built in 1879.

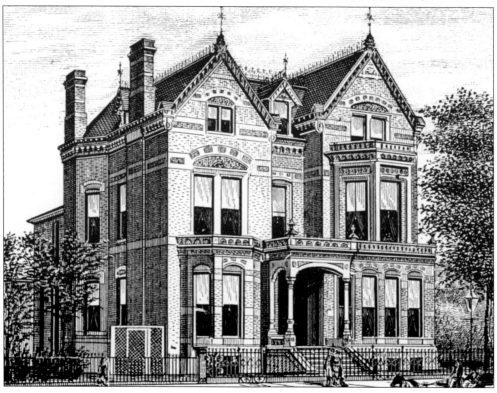

This is Mamie C. Burke's graduation photograph from Holy Trinity School. According to the 1891 edition of the Detroit city directory, Benjamin A. Nolan was principal of Newberry School, which was situated at West Twenty-ninth Street near Jackson Street and had been constructed in 1887. Nolan had been principal there since 1889. In 1891, Burke was listed as a teacher at Newberry School. It is assumed that she first became acquainted with Nolan, her future husband, at this time. She is interred at Mount Olivet.

Benjamin A. Nolan was born December 5, 1861, and died March 12, 1925. When he was buried at Mount Elliott Cemetery, he joined three generations of ancestors. His great-grandfather William Nolan came to Detroit from Roscommon, Ireland. Benjamin A. Nolan received a master's degree in pedagogy from Detroit College (now University of Detroit Mercy). He was one of the first intermediate school principals in the Detroit public school system. In 1927, the Benjamin A. Nolan Middle School was built at 150 East Lantz Street. First buried at Mount Elliott, he was moved to Mount Olivet.

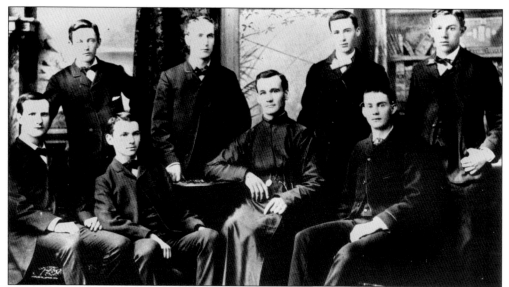

Members of the first graduation class of Detroit College, 1883, from left to right are (first row) Benjamin A. Nolan, John A. Russell, the Reverend J. P. Frieden (Society of Jesus), and James W. Kearns; (second row) W. H. Reaney, T. C. McKeogh, James E. Lacroix, and Conrad Sporer. Nolan was first interred at Mount Elliott Cemetery, where the Lacroix family also has many burials. (RM.)

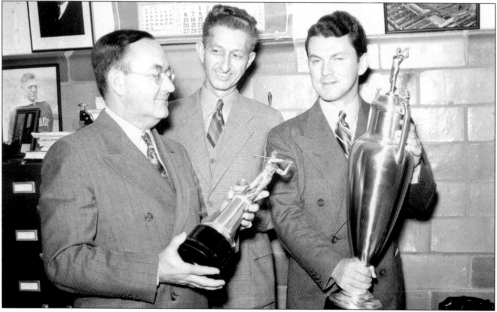

Judge John P. Scallen (right) was born around 1889; died February 4, 1972; and was buried in section E, lot 45. John was the son of Peter Scallen. He retired on December 31, 1966, from the position of recorder's court judge. He was known as the "father of football" at the University of Detroit. As a youth, he was a skilled athlete with aspirations of becoming a professional baseball player. He was assistant dean at the University of Detroit College of Law for several years. He retired at age 76, when an amendment to the state constitution allowed judges to serve only until the age of 70. He had been on the bench 36 years. He and his wife Kathleen had the following children: John P., Josephine T., Anne Marie, William R., Kathleen M., and Paul F. (DNC/WRL.)

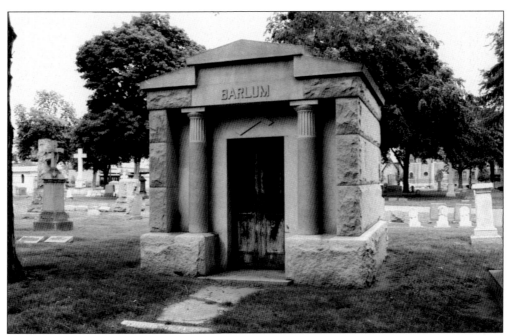

The House of Thomas Barlum was established in 1869, selling fresh and salted meats. Barlum owned a meat store on Cadillac Square. Thomas Barlum was born in 1839; died July 18, 1925; and was entombed in the Barlum mausoleum in section C, lot 14. His sons Thomas J. Barlum (also buried in Mount Elliot Cemetery) and John J. Barlum (buried in Mount Olivet Cemetery) inherited the bulk of his estate and built Barlum Hotel and Barlum Tower in the late 1920s. Barlum Tower is now known as Cadillac Tower.

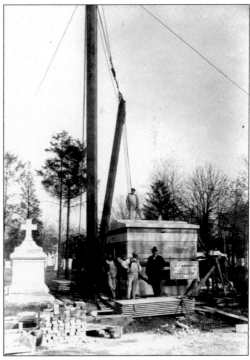

Pictured here is the construction of the private mausoleum of Judge James Phelan (1855–1915) in section M, lot 181. The contractor was M. F. Gardner. Phelan was a railroad laborer who spent most of his spare time umpiring ball games at the hay market, later Tiger Stadium. He became justice of the peace in 1889 and an associate judge of recorder's court in 1893. In 1877, he married Mary O'Connor, who died several years later. William Phelan, his seven-month-old son, also died. (MECA.)

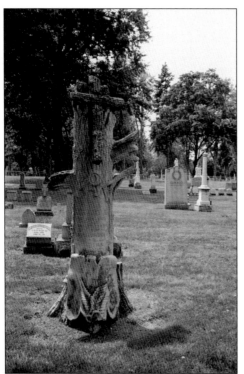

James George O'Neil's burial lot, in section N, lot 131, is graced with a tree-stump monument. He was born October 1, 1820, in Liverpool, England, and died May 11, 1882. His wife Rose Ann Baugh was born October 20, 1830, and died February 10, 1910. As seen here, tombstones often feature inscriptions, design motifs, and symbols that offer meanings to the life lived by the deceased. The art of carving tree-stump tombstones has been practiced since the 1850s, with its popularity peaking in the 1890s.

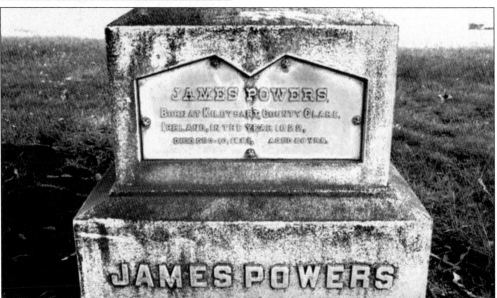

This photograph shows the base of the zinc monument memorializing James Powers (1822–1881) who was born in Kildysart, County Clare, Ireland. The monument is located at section 21, lot 162. The purchasers could choose from a list of inscriptions and plaques and could have epitaphs or inscriptions personally created. Several designs selected for Mount Elliott Cemetery burials include a leaf; symbols of faith, hope, and charity; a child dramatically embracing a cross; shaking hands; and the tapered, hollow column that is swaged with deep folds that end in tassels. Some researchers called zinc monuments "zinkies" or "poor man's granite."

The mausoleum of Thomas H. Welch is pictured here. Born September 10, 1860, Welch died November 21, 1952, and was buried in section A, lot 172. He took a four-and-a-half-year course at Detroit Business University and completed it in three months and 14 days. In 1915, Welch and his sons operated under the name of T. H. Welch Company. He was so knowledgeable and well respected and his judgment in appraising properties was so valued that he was typically paid $100 per minute. He married Marion M. Craig on April 16, 1895.

Michael W. Dillon was born March 25, 1855; died July 11, 1937; and was buried in section M, lot 436. He grew up in Kentucky. In 1879, Daniel Scotten lured him to Detroit with a job at Scotten, Lovett and Company, where he earned $1.25 per day as a leaf expert. In 1901, Scotten-Dillon Company was formed. Scotten died in 1910, and Dillon assumed active management of the company as president. In 1880, Dillon married Margaret Lahey.

Thomas Nester (1833–1890) was buried in section B, lot 79. In 1865, he and two others formed a partnership, buying their first tract of timberland of about one and a half million acres. After Nester's death, his vast lumbering operations were passed down to his sons and brother Patrick Nester. In 1860, he married Margaret Mann (or Mahon). Thomas and Margaret had the following children; George, Mary, Thomas, John F., and Frank P. He left an estate of $3 million.

Patrick Blake was born November 5, 1833; died August 20, 1903; and was buried in section M, lot 402. At age 14, Blake came to Detroit where he worked first as a shoemaker and later as a furniture dealer. In 1865, he started his own undertaking business at First and Abbott Streets. Eventually three of his sons—William F., Frank J., and Charles A.—joined the family business. He fathered 12 children. Blake handled the reinterment of Fr. Gabriel Richard when old Ste. Anne de Detroit was torn down. The most unusual funeral he directed was preceded by the wedding of the daughter of the deceased; prior to the service, a family member told him Mrs. Axtel's daughter was to be married and that she wanted him present. So Blake stepped into a little bedroom where the wedding took place and then went to the parlor where the funeral proceeded. Four years later, the daughter died, and Blake buried her.

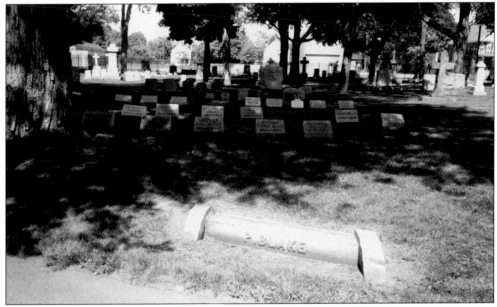

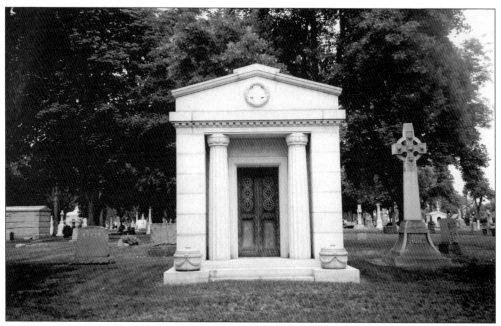

William F. McDonald died April 27, 1919, at age 42 and was entombed in a mausoleum in section B, lot 9 in the Owens-Bunbury vault. According to the city directory of 1915, McDonald was a heating engineer and head of William F. McDonald Company.

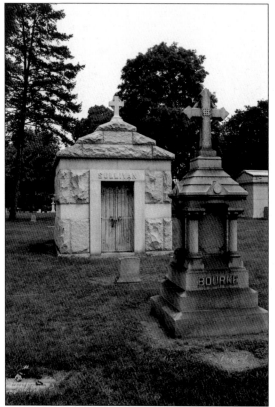

Michael J. Bourke was born March 27, 1857; died June 7, 1939; and was buried in section B, lot 80. Bourke began his career as a clerk on one of Ward Company's Lake Superior line boats in 1872. In 1886, he wed Mary the daughter of Thomas Nester. Soon afterward, he took charge of the lumber business established by his father-in-law in Baraga, Michigan.

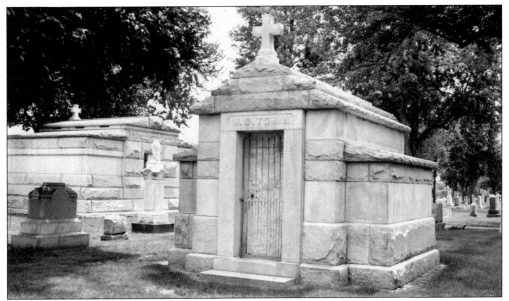

Pictured here is the mausoleum of William D. Tobin, who died June 28, 1898, at age 80. The mausoleum is located in section G, lot 23. Tobin is listed in the city directory of 1884 as a vessel captain. The Romanesque style, distinct with its massive scale, squared-off surfaces, and rusticated (rough hewn) stonework is showcased by mausoleums housing the following persons: W. D. Tobin, Thomas H. Welch, P. B. McCabe, and Lillian Petz Van Overmeer. The McCabe mausoleum has a post and lintel doorway, the Van Overmeer mausoleum has columns topped with plain Doric capitals, and the Welch mausoleum has columns with decorative Corinthian capitals.

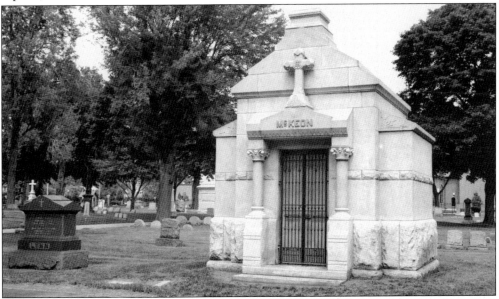

Stewart C. Griswold, who was born March 17, 1877, and died May 26, 1930, is entombed in the McKeon mausoleum, located in section C, lot 27. Griswold was admitted to the Michigan Bar on September 24, 1902. He acted as secretary to Lt. Col. Henry A. Green of the War Department in Washington, D.C., from 1900 to 1902 and was a member of the law firm of Frazer, Griswold, and Slyfield from 1907 to 1913. Griswold married Mary Helen C. McKeon on February 25, 1911.

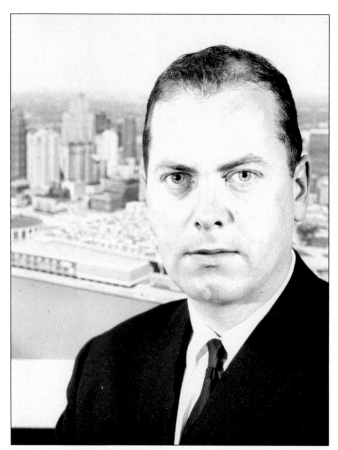

Mayor Jerome Cavanaugh was born June 16, 1928; died November 27, 1979; and was buried in section E, lot 56. Cavanaugh was mayor of Detroit from 1962 through 1970. As mayor, he secured more than $42 million in federal funds for poverty programs. He was the city's mayor during the race riot, which began on July 23, 1967. Four days later, Cavanaugh and Gov. George Romney invited 500 Detroiters, a cross-section of the community, to a meeting. Out of this meeting grew the New Detroit Committee, an urban coalition to help prevent future problems. (DNC/WRL.)

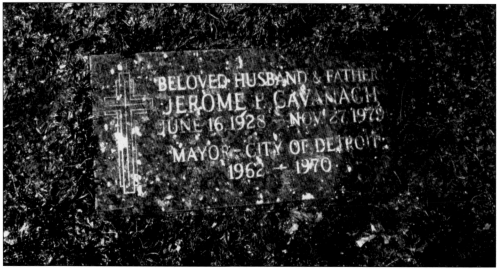

Three

CANADIENS

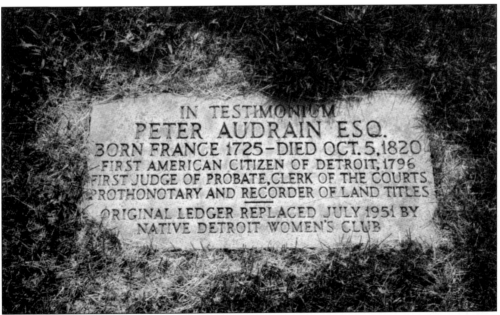

Peter Audrain (Pierre Andraends, Esq.) was born in 1725; he died October 5, 1820; and was buried in section 71, lot 507. Chief notary of Wayne County in 1796, Audrain was a probate judge from 1796 through 1809, secretary of the Corporation of Detroit in 1802, clerk of the territorial court from 1805 through 1819, and registrar of United States Land Office in Detroit from 1806 through 1820. He came to Detroit in 1796, at age 71, when Detroit was only a fort and village of about 300 houses. He played a key role in virtually all of Detroit's legal affairs. At 94 years of age, lawyers complained that the records of the supreme court were in great disorder as a result of his neglect, and he was removed from office in 1819.

This advertisement touts Elsey Monuments, belonging to Samuel Elsey, who was born in England in 1835. In 1870, Elsey resided in Detroit with his wife Sophia and their children, Maria, Edia, Elizabeth, Charles, and Mary, all of whom were born in Michigan. Samuel and Sophia also lost one child at a young age: Samuel Elsey, who died September 10, 1876, at the age of one year and 10 months from diphtheria. (MECA)

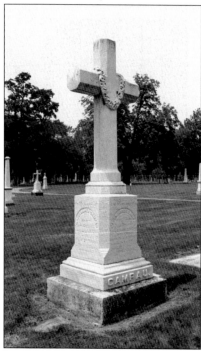

The Campau monument is found in section 19, lot 166. Maj. Jacques Campau was born August 24, 1793, and died November 10, 1871. He was 78 years old. His wife was Josette Chene, who died January 12, 1881, at age 83.

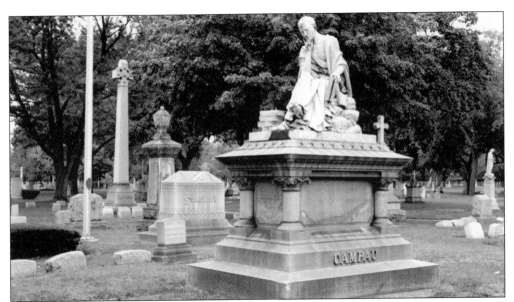

This likeness of Daniel Joseph Campau Sr., son of Joseph Campau, was cast in bronze by the Bureau Brothers in Philadelphia. Born November 18, 1813, Daniel died February 14, 1883, and was buried in the family lot at section E, lots 50 and 59. He was a self-made man, having received no financial assistance from his famous father, the wealthiest man in Michigan, as he struggled to make it on his own. In 1842, he became a member of the first board of education of Detroit, and the board's inspector of schools. He also served as the board's treasurer for six terms. He was treasurer for the City of Detroit, 1842–1844, and Wayne County treasurer, 1845–1850. He married Mary Frances Palms, and they had three children: Daniel Joseph Jr. (who married Katherine DeMille at age 72 and is buried in Elmwood Cemetery), Louis Palms, and Adelaide Thompson, wife of former Detroit mayor William G. Thompson.

The LaCroix monument was made by S. Elsey, located in the south end, for two children of the LaCroix/Campau family who are interred next to their parents' ledger. Henry J. LaCroix married Mary Ann Campau, and their daughter Marie was born October 9, 1852, and died October 20, 1857. Their son, Joseph LaCroix, lived from February 1857 until October 1859.

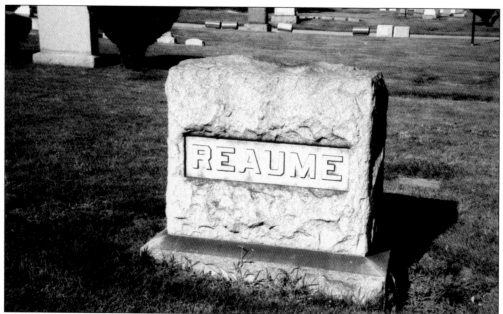

In *Legends of Le Detroit*, published in 1889 and transcribed by Linda Ball, the Reaume family is mentioned. Some of the most prominent families in Canada and the United States descend from the Reaume family. One branch of the Reaumes was stationed in Detroit, headed by British Army officer, Louis Reaume. He was married in 1780 to Marie Charlotte Barthe, the daughter of Pierre and Charlotte Chapoton. He was killed only two weeks after his marriage, leaving his wife a widow at only 17 years old. She later married Louis des Comptes Labadie.

Monique (1787–1851) and Antoine (1784–1858) Beaubien are buried in section 103, lot 702. Antoine Beaubien was the son of Louis Antoine Beaubien. In 1829, he married Monique des Comptes Labadie, daughter of Pierre Labadie. Childless, Monique Beaubien met the needs of the city's children throughout her life. Her generosity provided for the French Female Charity School for 40 poor children, which the Poor Clares taught. She gave land and funds to other religious orders as well.

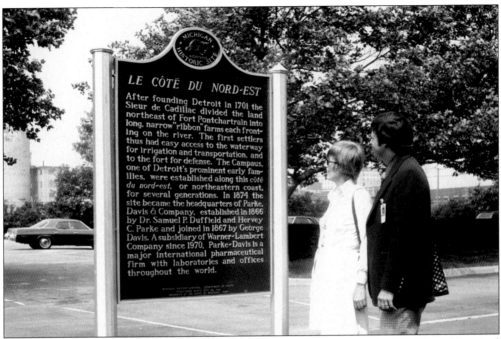

Erected at the foot of Joseph Campau Street and the Detroit River, this Michigan historical marker commemorates the French settlement along the Detroit River. It reads in part, "After founding Detroit in 1701 the Sieur de Cadillac divided the land northeast of Fort Pontchartrain into long narrow 'ribbon' farms each fronting on the river. The first settlers thus had easy access to the waterway for irrigation and transportation, and to the fort for defense." (DNC/WRL.)

Pierre Provencal was born about 1795, died in 1869, and was buried in section A, lot 180. Provencal left the mercantile business in 1819 because of failing health and bought land in Grosse Pointe so he could farm in the country. He built a French farmhouse at the foot of what is presently Provencal Road in Grosse Pointe Shores. At the age of 36, he married 18-year-old Euphemia St. Aubin. Having no children of their own, they eventually founded a school in their home for children orphaned by the cholera epidemics of the 1830s and 1840s. A confessional box and an altar were built in their parlor that served as a church for a period of time. After 14 years of marriage, they had a daughter, Catherine, who eventually married Judge James Weir. Around 1900, the old farmhouse was moved to Kercheval Avenue and is known today as the Weir house.

Among the members of the extended family buried near the Chase-Casgrain monument are Charles W. Casgrain, Marie Chase Casgrain (1826–1886), and Catherine Baillie De Messeir the wife of Thomas Chase (1798–1864). The graves are in section 106, lots 728.

This photograph was taken April 20, 1930, after the last mass at old St. Aloysius in Detroit. Charles W. Casgrain participated in the first and the last mass at the church. (DNC/WRL.)

Gabriel Chene Sr. was born in 1770; died February 1, 1830; and was buried in section 20, lot 153. Originally buried on the Chene farm, his remains were reinterred in 1854. Chene married Archange Campau, daughter of Jean Baptiste Campau, the original owner of the land that became Chene farm. Chene was prominent among Detroit's French settlers. At the time of Chene's death, the farm consisted of 636 feet of waterfront property and went three miles back from the river.

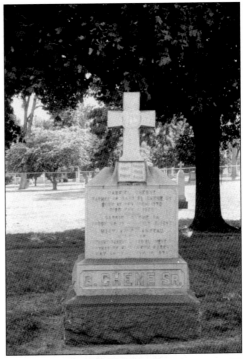

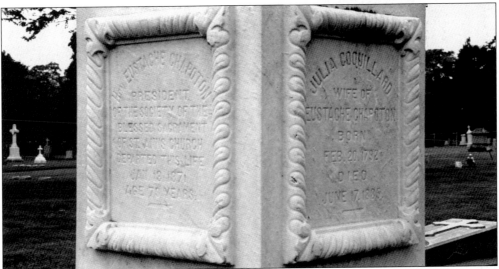

Eustache Chapoton was born about 1792; died January 13, 1871; and was buried in section 60, lot 1025. Chapoton opened a tavern at the foot of Woodward Avenue but gave it up after a sermon at Ste. Anne de Detroit denounced the evil of selling liquor to Native Americans. Chapoton then became a builder. He knew nothing of math and could write very little, but his wife helped him learn to count with matches. He became a master builder, which amassed him a fortune. Chapoton married Julia Coquillard (who was born February 20, 1792, and died June 17, 1885), and their children were Alexander, Benjamin, William, Augustus, Therese, and Julia. Eustache and his brother-in-law Thomas Coquillard built SS. Peter and Paul church on Jefferson Avenue at St. Antoine Street. He was on the Detroit Common Council in 1844 and was a trustee of Ste. Anne de Detroit, 1835–1870.

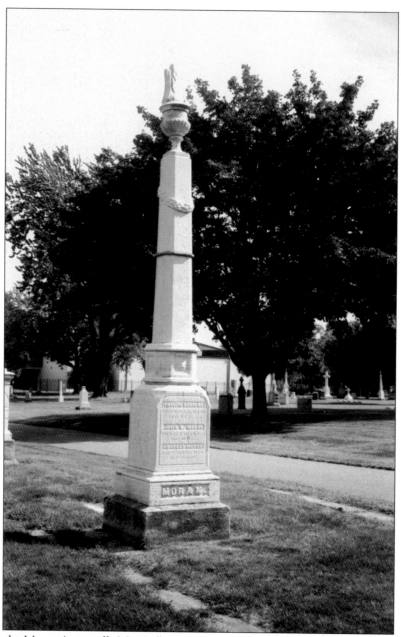

Judge Charles Moran (originally Morand) III was born in 1797 and died October 13, 1876. Moran was buried in section 59, lot 1028. The son of Charles and Catherine Vessiere de la Ferte Moran, his grandfather Charles Claude came to Detroit in 1751 and settled on what became known as the Moran farm. The Moran farm was nearly 500 feet wide and went three miles back from the Detroit River. After receiving a formal education, Charles Moran inherited the family farm. At the age of 15, he enlisted in the army and fought in the War of 1812. He was a member of the first state constitutional convention and served two terms in the state legislature. In 1838, he was appointed as one of a board of advisors to look after the interests of the University of Michigan. In 1822, he married Julia Dequindre, with whom he had five children before she died. He left an estate of $4 million.

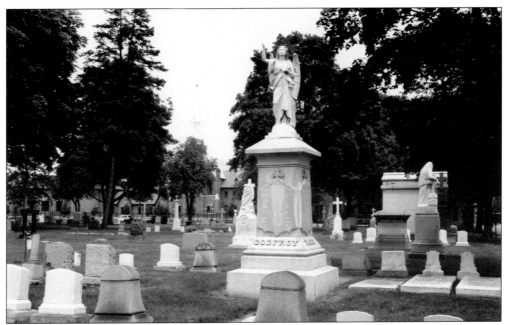

Peter (Pierre) Godfroy was born June 15, 1797; died May 21, 1848; and was buried in section B, lot 15. Godfroy, a member of a wealthy French family, was known as "Le Prince." He was part of the well-known firm of P. and J. Godfroy, fur traders. He was township supervisor from 1827 through 1841, county commissioner in 1842, and a representative in the state legislature in 1843. In 1824, he married Marianne Navarre Marantette.

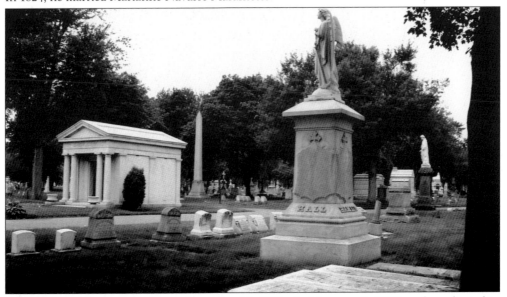

Theodore Parsons Hall was born December 15, 1835; died January 3, 1909; and was buried in section B, lot 15. Upon graduating from Yale University in 1856, he joined the banking house of Thomson Brothers, which founded the First National Bank and Chase National Bank of New York during the Civil War. In 1860, he married Alexandrine Louise Godfroy. In 1880, he retired and purchased a beautiful country estate, Tonnancour, built around 1880, in Grosse Pointe Farms. He was very interested in local history and genealogy.

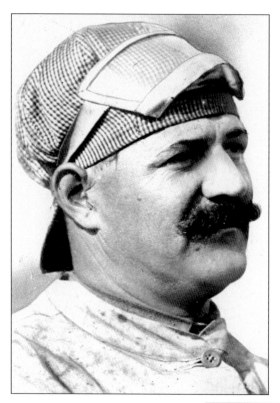

Louis Chevrolet is buried in Indianapolis, while wife Suzanne (1888–1966) and son Alfred (1912–1971) are buried in section 71, lot 508 of Mount Elliott Cemetery. In 1907, Chevrolet's racing reputation led to his first encounter with W. C. Durant, the "father" of General Motors, who put his genius to work on the creative design concepts. Louis's son, Alfred Chevrolet, had no interest in achieving fame, prominence, or influence in the automotive industry. Instead he worked quietly on the assembly line. (DNC/WRL.)

Detroit in Its World Setting was first published to commemorate the 250th birthday of Detroit. Originally published in 1953, after the anniversary it was revised and updated to mark the city's 300th birthday in 2001. Culled from a wide variety of references, Detroit in Its World Setting is a time line that offers readers a new appreciation of Michigan history, by setting life in the Motor City into the context of world affairs. The shield shows the three ruling powers of Detroit: the eagle and stars of the United States, the lion for British rule, and the fleur de lis for the French reign.

Four

FLEMISH OF FLANDERS

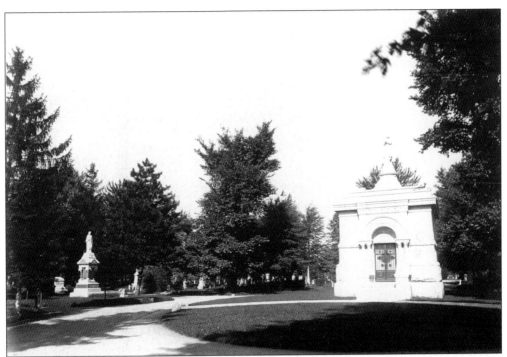

Father Bonaventure oversaw the building of the Capucian monastery and chapel while living in a one-story brick building in Mount Elliott Cemetery. He built a small chapel where the Francis Palms mausoleum now resides. Peter Paul Lefevre, with Bishop Spalding, was instrumental in founding the American College at Louvain in 1857 in Belgium. The first Belgian presence in Detroit was these missionary priests. Lefevre died March 4, 1869, and is buried in SS. Peter and Paul church of Detroit, built by George D Mason. Mason also designed the Palms monument, Grand Hotel, Gem Theatre, Masonic temple, and Detroit Yacht Club. (BN.)

Francis Palms (born in 1810; died November 24, 1886; and entombed in section S in the Palms mausoleum) was the son of Ange Palms, a quartermaster in Napoleon's army. The family came to Detroit in July 1833. Francis Palms and his sister Mary Frances—who later married Daniel Joseph Campau—stayed in Detroit while Ange Palms, three of his sons, and a daughter moved to New Orleans. In 1836, Francis Palms married Martha Burnett, who died soon after the birth of Francis Palms Jr. The infant was sent to New Orleans to be raised by his grandfather. In 1840, Francis Palms married Catherine Campau, daughter of Joseph Campau. The couple had one daughter, Clotilde. Francis used his money to buy and sell land, acquiring 40,000 acres in Macomb and St. Clair Counties. He sold this land in small parcels 10 years later, making nearly $4 million. The Palms residence was located at 357 Jefferson Avenue and was built in 1848. (SF.)

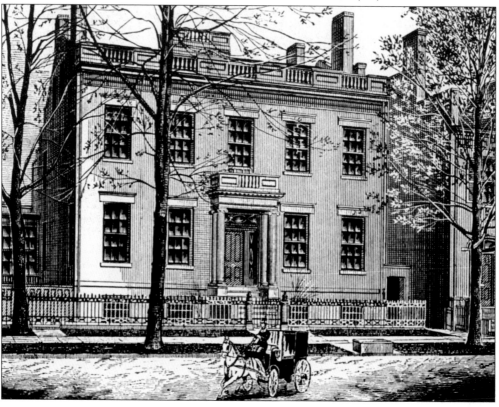

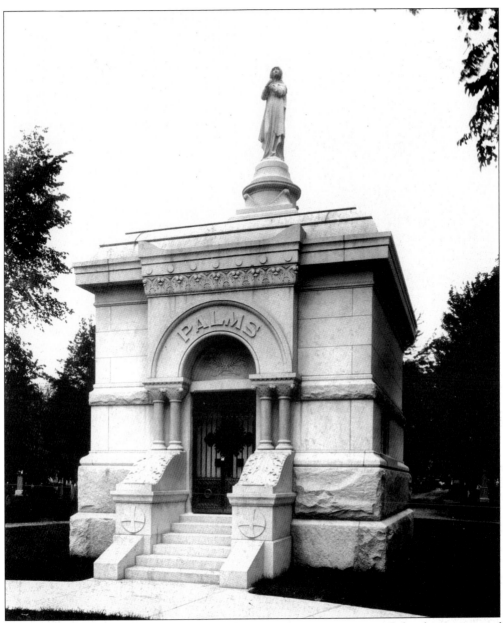

The Palms mausoleum was designed by architect George Mason. Francis Palms become one of the largest landowners in the country. Because he retained mineral rights to lands sold in the Upper Peninsula, he was the owner of many valuable mining districts in the Gogebic range. A railroad was built, connecting the two Michigan peninsulas, through the enterprise and capital of Francis Palms and James McMillan. In the mid-1880s, Palms constructed a large number of business blocks in Detroit. He also built the Palms Apartments, the Palms House on East Jefferson Street, and the Palms Theater. He was president of Michigan Fire and Marine Insurance Company and had connections with Galvin Brass and Iron Company, Union Iron Company, and the Vulcan Furnace and Peninsular Land Company. He was vice president and a director of Detroit, Mackinac and Marquette Railroad. Palms left an estate of $7 million. (DPL/BHC.)

Henry De Smyter (1878–1945, section A, lot 133) is pictured here with his first wife, Sylvie De Smyter (1872–1899). Henry De Smyter and his wife had a son named Rene, and were members of Our Lady of Sorrows parish. Henry De Smyter was a founder of St. Charles Benevolent Society and was photographed with the six other founders, wearing their ribbon badges and proudly displaying their banner. Also buried at the De Smyter lot are two children, Renilda De Smyter (age four) and Stanley De Puydt (age three months). (SK.)

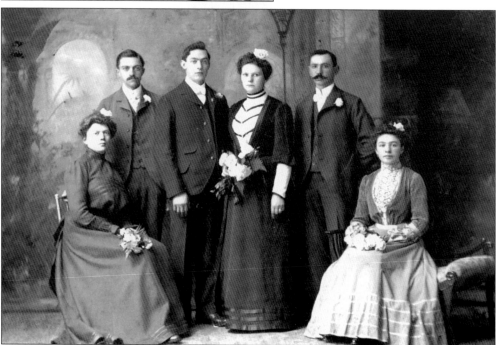

Henry De Smyter is pictured here with his second wife, Emerence De Smyter. She is seated on the left, with Henry standing next to her. It appears that Henry was a witness to the marriage depicted in this image. The other couples, most likely Belgian, are unknown. (SK.)

Pictured here is the Emerence De Smyter (1878–1945) funeral card. In Belgium, women use their husband's surname as well as their maiden name by hyphenating their maiden name onto their husband's surname. Letters arriving from Belgium would be addressed to Emerence De Smyter–De Puydt. Emerence De Smyter is buried on one side of Henry De Smyter and his first wife, Sylvie De Smyter, is on the other. (SK.)

Sacred F ·art of Jesus, have
n ·y on her.

✠

IN MEMORIAM

Emerence De Smyter

(nee DE PUYDT)

Beloved wife of Henry De Smyter
Born in Dadizeele, Belgium,
July 29, 1878,
Died in Mt. Clemens, Michigan,
December 30, 1945.

PRAYER

O Gentlest Heart of Jesus, ever present in the Blessed Sacrament, ever consumed with burning love for the poor captive souls in purgatory, have mercy on the soul of Thy departed servant, Emerence, but let some drops of Thy Precious Blood fall upon the devouring flames, and do Thou, O Merciful Savior, send Thy Angels to conduct Thy departed servant to a place of refreshment, light and peace. Amen.

Sacred Heart of Jesus have mercy upon her.

Immaculate Heart of Mary, pray for her.

St. Joseph, friend of the Sacred Heart, pray for her.

Heer en Vrouw Jean MADOU-VERLEDENS en kinders Hélène en Jacques;
Heer en Vrouw Camiel VERLEDENS-DEVODDERE en zoon Roger;
Heer en Vrouw René DE SMYTER-VERLEDENS en kinders Georges en Bernadine;
Heer en Vrouw Leon BRUNEEL-VERLEDENS en kinders Jacqueline en Willy;
Heer en Vrouw Jules WITHOUCK-VERLEDENS en kinders Simone en Henri;
Heer Valère VERLEDENS;
De familiën VERLEDENS en VANGHELUWE

melden Ued. met diepe droefheid het pijnlijk en onherstelbaar verlies welke zij komen te ondergaan door het afsterven van hunne teerbeminde Moeder, Schoonmoeder, Grootmoeder, Znster en Tante

VROUW

Sidonie VANGHELUWE

weduwe van Jan-Aloïs VERLEDENS,

geboren te Ledeghem den 16 Maart 1864 en overleden te Moorslede den 5 December 1936,
gesterkt door de H. Sakramenten der stervenden.

De plechtige Lijkdienst, gevolgd door de begraving, tot dewelke Ued. vriendelijk wordt uitgenoodigd, zal plaats hebben Donderdag 10 December, om 9 ure, in de parochiale kerk van St. Martinus te Moorslede.

Vergadering ten sterfhuize, Statiestraat, 20.

Bid God voor hare Ziel.

Moorslede, den 7 December 1936.

Martha De Smyter Madou

Druk A. De Wispelaere, Moorslede.

When a death occurred in Belgium, an invitation to the funeral (*doed brieven*) was sent in the mail, a custom that is still practiced today. When the black-edged envelope was opened, there was a standard message of sympathy inside and a list of the surviving relatives and their relationship to the deceased. This letter announced the death of Martha De Smyter's father, Jean-Alois Verledens, in Moorslede, Belgium, on March 30, 1931. The closing line reads, "Remember him in your prayers." (SK.)

Hector Van de Vyver (1909–1995) was born in Antwerp, Belgium. He was the son of Emil and Virginia. He immigrated to the United States with his parents and brother, Rene, in 1916. He wed Irene Zygailo in 1940, and they shared 55 years of married life. They had six children, two of which are buried with them, Sister Franciline and son Ronald. Hector Van de Vyver is pictured here at the Mount Elliott Cemetery office, where he worked for 33 years. The family is buried in section 119, lot 830. (SJVV.)

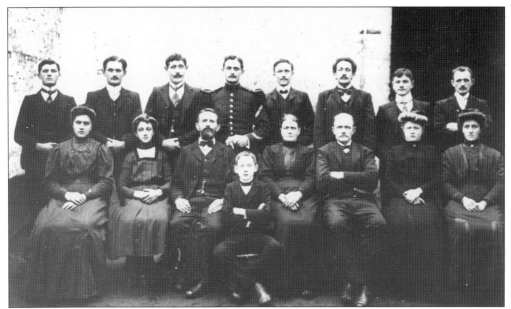

Emil Van de Vyver is standing in his military uniform among his 13 brothers and sisters in Lokeren, Belgium. Emil took his family back to Belgium to visit after World War I. Hector Van de Vyver wrote a book about this visit back to Belgium for his grandchildren. Titled *From Belgium to America*, he told the story of sleeping in his grandmother's hayloft and his first taste of cherry beer called *krieken bier*. (SJVV.)

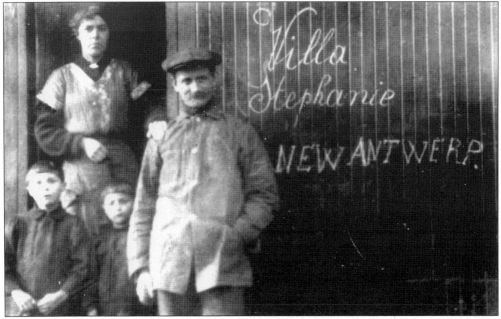

Hector Van de Vyver is pictured here with his brother, Rene, and parents, Emil (1880–1970) and Virginia (Sorrels) Van de Vyver (1881–1959). They immigrated to the United States with a promise of farmland. They lived in a boxcar while being tenant farmers before coming to Detroit. Emil kept his humor, and the "Villa Stephanie" was written in his fine banker's handwriting. Both Emil and Virginia are buried at Mount Elliott Cemetery. (SJVV.)

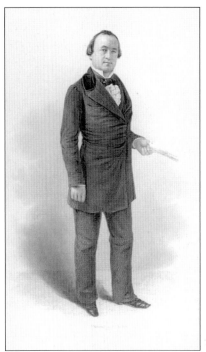

Judge James A. Van Dyke (1813–1855) was of Dutch
ancestry, a neighbor to the Belgians. His burial
is documented in the city death returns, but the
location is not known. A visitor to Mount Elliott
Cemetery in 1906 wrote, "In a large, old-fashioned
lot, overgrown by weeds and wild bushes, rests this
once prominent mayor. He was elected mayor in
1847. Today his grave, without a distinguishing mark
to guide a stranger, tells nothing of his past fame."
Also buried at Mount Elliott is his granddaughter
Josephine Brownson. Josephine Brownson was also
the granddaughter of Orestes Brownson (1803–1876),
a religious philosopher. She embodied the talents
of both families in her career, as the founder of the
Catholic Instruction League. Her grandfather Orestes
Brownson was removed from Mount Elliot and
interred in the Brownson Chapel, at Notre Dame
University. The Van Dyke residence was at
308 Jefferson Avenue and was built 1836–1872. (SF.)

Five

GERMAN VOLKSDEUTSCH

Anthony Weiler (born around 1858; died June 29, 1907; and buried in section L, lot 5) was an alderman and one of the most colorful figures in the history of city politics. He operated a wholesale and retail liquor business at Beaubien and Clinton Streets. With his wife Anna, he had four children: Joseph, Frank, George, and Lillie. (BN.)

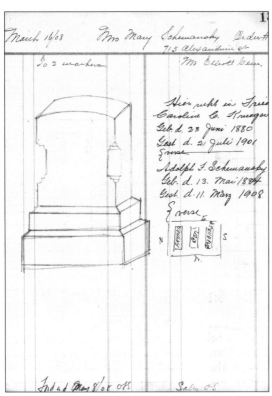

Marie Schemansky (1854–1917) was the wife of Jacob Schemansky. The circular crest on her tombstone reads, "In Memorial Woodman's Circle." This was the women's branch of an insurance society that had fraternal group features. Founded by Joseph C. Root in Iowa in 1883 to offer financial support to families whose breadwinner had died, Modern Woodman of the World ensured that each grave site would have a tombstone. Root prepared funeral ceremonies for deceased members that came to include hymns, remembrances, and the dropping of flowers and evergreen sprigs over the casket. It is not known if this was performed at Marie Schemansky's grave site. The women's auxiliary symbols included the axe, beetle, and wedge (signifying industry, power, and progress), in front of a shield with stars and stripes. Its motto is *Dum, Tacet, Clamat* or "though silent he speaks." (BN.)

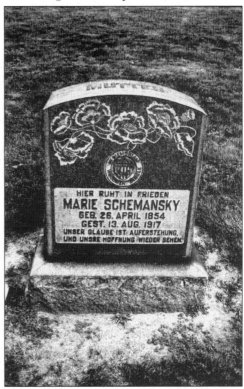

The Christopher Schoenherr family of Detroit is believed to have roots in Alsace-Lorraine, the area in Europe that shares both French and German heritage. Their monument is graced with the symbols of faith, hope, and charity. Faith, the belief in God, is symbolized by the cross; hope, trust in God, is symbolized by the anchor; and charity, the love of God, is symbolized by the heart. This monument was made by the Reimers and Feldpausch Marble and Granite Works. Located at 914 Gratiot Avenue near McDougall Street, Conrad Feldpausch advertised that all orders for cemetery work were promptly attended to, at reasonable prices. The marking of monuments fell out of practice by the early 20 century. (MECA.)

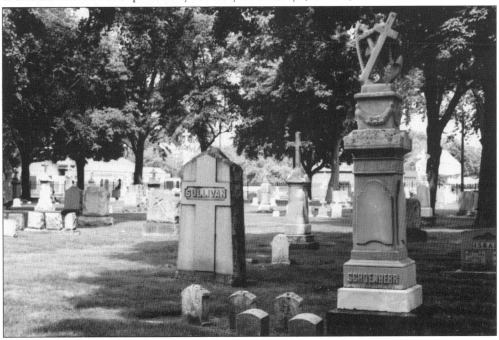

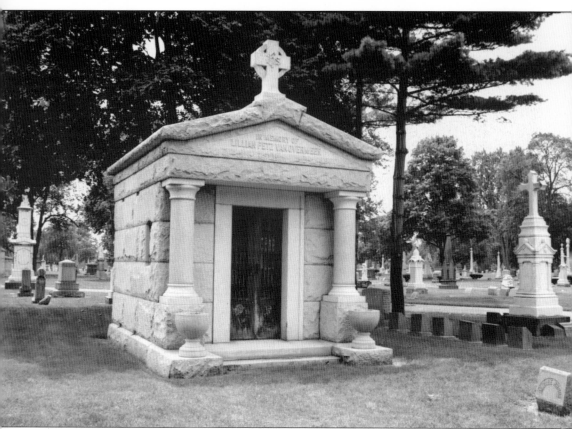

Lillian Petz Van Overmeer's mausoleum, in section A, lot 115, is best described as Romanesque, featuring the massive scale, squared-off surfaces and rusticated stonework that mark this distinct style. The same features are also found in other mausoleums: W. D. Tobin, Thomas H. Welch, and P. B. McCabe. Joseph Petz (1841–1883), who was a jeweler, is buried here, along with his wife Sophia. He was also a partner with his brother Francis in the F&J Petz jewelry store from 1865 to 1883.

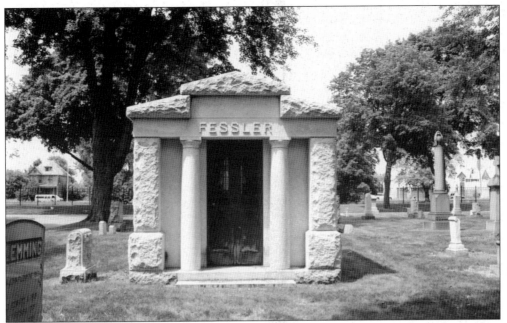

The Fessler mausoleum, in section W, lot 167, is the final resting place for three brothers and their families: Henry W. Fessler (died November 25, 1913, at age 33, buried in section W, lot 167), John Fessler (died August 9, 1890, at age 55), and Joseph Fessler (died May 17, 1961, at age 89). The city directory indicates that John Fessler was a woodworker and that Joseph Fessler was a tinsmith, clerk, and operator of a saloon at 488 Meldrum Street with Henry Fessler.

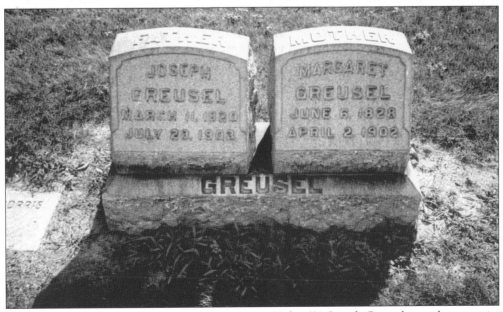

Pictured here are the Greusel tombstones in section 91, lot 621. Joseph Greusel was a letter carrier from Bavaria, and his wife Margaret Greusel was of French Canadian decent. There is a worn limestone marker to the right of their tombstones that faintly reads "children." Their son Joseph Greusel Jr. drowned in the 1880 *Mamie* boating accident with the Holy Trinity parish outing.

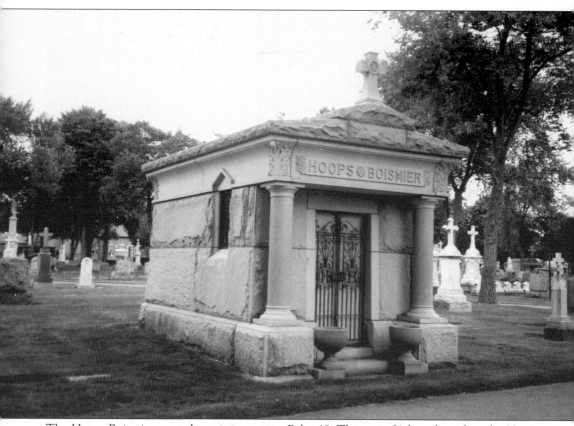

The Hoops Boismier mausoleum is in section P, lot 18. There are 21 burials within the Hoops Boismier private mausoleum. They are, in order of burial, Hayes B. West (1882), Josephine Hoops (1910), Charlotte Reaume (1911), Joseph Hoops (1911), Josephine Hoops (1911), Sophie Boismier (1911), Noah Boismier (1911), Annie Boismier (1911), Charlotte Boismier (1919), Philip Hoops (1932), Lorraine Craig (1989), and Calvin Craig (1996).

Frank Huetteman (born in Endorf, Germany, 1843–1922) and wife Bernadine Wessel had five children: Bertha, Frank, Theodore, Josephine, and Leo. Frank was in Detroit when he died at 79 years old in 1922. He was a member of St. Charles parish at the time of his death. His brother Joseph Huetteman (1840–1921) was a member of St. Joseph's parish. According to *Detroit of Today: The City of the Strait,* "Joseph Huetteman is greatly respected in trade and other circles. He married Theresa November 16, 1869, at St. Joseph's Catholic Church at 1828 Jay Street." They had four children Frederick, Bernadine, Frank John, and Bernard. Joseph first operated a grocery store and meat market at Russell and Macomb Streets. Joseph's son Frank John was in business with him for 16 years before going out on his own as a wholesaler in cheese and butter. Frank John introduced new cheeses to Detroit that are now known as pinconning and frankenmuth. Their graves are in section A, lot 147. (Right, BN; below, CS.)

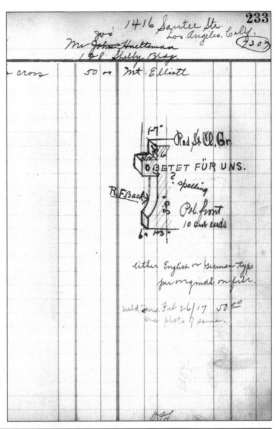

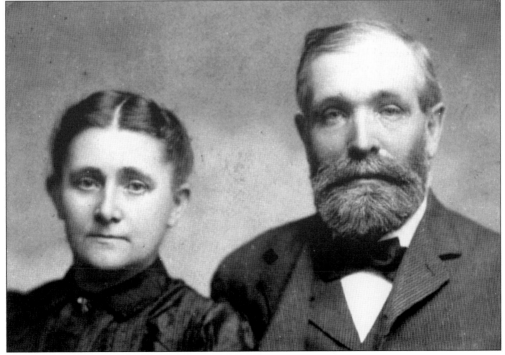

Anton Dunnebacke, born around 1843; died January 31, 1912; and buried in section A, lot 108, was born in Germany. He kept a family hotel for 21 years, retiring in 1900. He also held an interest in Ekhardt and Becker Brewing Company. Joseph Dunnebacke, Anton's father, (born around 1815; died August 19, 1878; buried in section 49, lot 381) was in the saddler trade in 1848 and worked in the same store until his death. Joseph's second wife, Catherine A., died March 2, 1892, at age 62.

The Dunnebacke family monument lot in section A includes Ferdinand E. (died January 2, 1899, age 75), Anna Elizabeth (died April 15, 1897, age 59), John (died November 17, 1887, age 26), Joseph E. (died February 7, 1874, age 7), Ferdinand (died March 2, 1863, age 3), Alexis (died May 18, 1819, age 36), and Albert (died September 21, 1927, age 55).

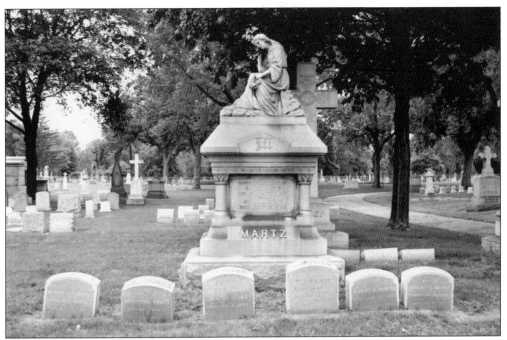

Alfred F. Martz (born about 1898; died December 7, 1976; and buried in section M, lots 337 and 338) was the first manager of Detroit Bank and Trust. He was also vice president of Detroit Brewing Company, 1933–1947. His brothers were Arthur, Louis, Edward C., and Oscar. His children were Alfred Jr. and two daughters. Louis Martz is pictured here with O. A. Martz, Lou Luckoff, and R. J. Anderson. (DNC/WRL.)

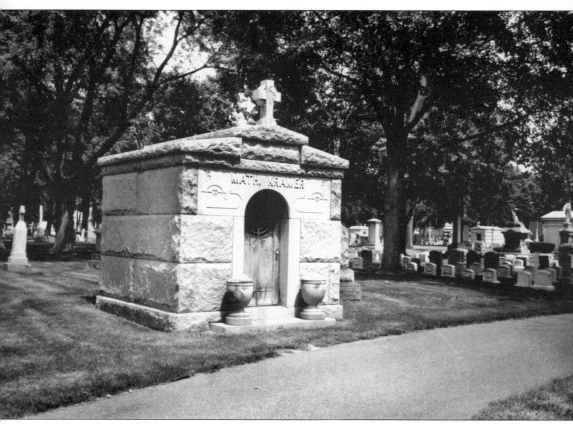

This is Matthew Kramer's mausoleum in section G, lot 42 (born January 1, 1833, and died May 30, 1889). Detroit's *Michigan Volksblatt* newspaper was published weekly in German by Matthew Kramer and Company. When Matthew died in 1889, his widow became publisher of the *Michigan Volksblatt*. Philip Kramer and his son Matthew were also involved with the newspaper. City directories 1862–1889 show that Matthew Kramer and Company was owned by Matthew (1860–1917) and Philip Kramer (died 1884).

Anton Pulte (born December 4, 1816; died August 10, 1891; and buried in section 126, lot 887) was born in Mecklinghausen, Westfalen, Germany. He came to Detroit on January 4, 1837, and in 1842 purchased a restaurant in the basement of the old city hall. He sold it nine months later and bought a lot—now Cadillac Square—on which he built a general store with partner Peter Henkle. He later went into the wholesale grocery business on the southwest corner of Monroe and Farmer Streets, where he remained for 25 years. Casper Schulte was a partner for six months, and Pulte also brought in his sons as partners. In 1876, he built a large block on Farmer Street. His first wife, Ionis Gabler, died in 1862. He then married Elizabeth Strack around 1865; she died in 1896. His children included Sophia and Joseph.

F. G. MARSHALL,

Undertaker & Practical Embalmer

125 GRATIOT AVENUE,

DETROIT, - - - MICHIGAN.

(Telephone No. 1058.

This is an F. G. Marshall undertaking advertisement. A Detroit business directory reads, "Marshall was born in Germany, and is a member of the Rochester, New York School of Embalming, class of '83. He founded his present enterprise in 1881, and from the start became the recipient of a large and influential patronage. Several experienced assistants are employed, while 6 horses, 2 hearses and 22 carriages add to the completeness of equipment." (MECA.)

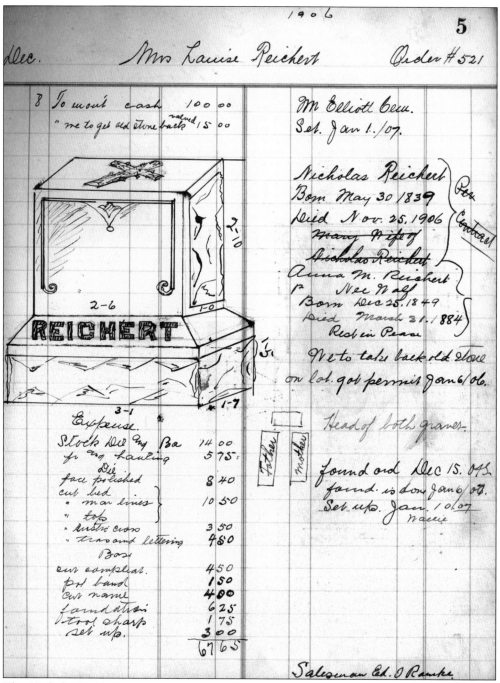

Dec. *Mrs Louise Reichert* Order #521

8 To amount cash 100 00
" me to get old stone back valued 15 00

Mt Elliott Cem.
Set. Jan 1./07.

Nicholas Reichert) Per
Born May 30 1839
Died Nov. 25. 1906) Contract
~~Mary Wife of~~
~~Nicholas Reichert~~
Anna M. Reichert
Nee Naly
Born Dec 25. 1849
~~Died March 31. 1884~~)
Rest in Peace

We to take back old stone on lot. got permit Jan 6/06.

Head of both graves.

Father Mother

found ord Dec 15. 0/5
found. is done Jan 6/07.
Set up. Jan 10/07
Nellie

Expense
Stock Del my Ba 14 00
for any hauling 5 75
Del
face polished 8 40
cut bed
" mar lines } 10 50
" top
" rustic cross 3 50
" tracing and lettering 4 50
Base
cut compleat 4 50
pol band 1 50
cut name 4 00
foundation 6 25
tool sharp 1 75
set up 3 00
 67 65

Salesman Ed. O Ranke

This Nicholas Reichert monument order was placed with Otto Schemansky by Louise Reichert of Jay Street. The United States census records the family in 1900 as living in Detroit Ward 11, Wayne County. Nicholas was the head of the house and was 63 years old. His birthplace was Germany. Living with him were his daughters Anna, age 27, and Louise, age 20. The monument is in section R, lot 97. (BN.)

Six

POLONIA

The Thomas M. Kuras monument, in section C, lot 57, honors a short but creative life (1950–1997). Kuras died of cancer on July 26, 1997, in his home in Birmingham, Michigan. His maternal and paternal grandparents were from Austrian and Russian Poland. On his headstone at Mount Elliott Cemetery are engraved words from the eulogy delivered by William M. Worden following the funeral mass: "He wore all of music as a seamless garment." Engraved at the top is the Gregorian notation for *In paradisum deducant te angeli*. This prayer, so well put into music in his admirable "Requiem," was frequently sung by Kuras at the end of funerals, using his own solo arrangement of the setting from the "Requiem" by Maurice Durufl, one of his idols.

Allan Treppa documented his ancestor's departure from Poland and early years in Detroit in *The Eaglet*, Volume 5, No. 3, published in September 1985. Martin Treppa was born in Witschlin (Wiczlino), West Prussia, on October 29, 1844, the son of Anthony Treppa and Frances Sampa. Martin left Hamburg on the *Prince Albert* on March 15, 1869. He arrived in New York on May 15, 1869. He witnessed his brother Anthony's marriage to Josephine Schemanska on August 22, 1870. Martin wed Margaret (Malgorzata) Kutny (Courtney) at St. Joseph's church on June 4, 1872. Fr. John F. Friedland officiated. Margaret's family was from Gudzidz, and they first settled in Canada before coming to Detroit in 1859. Like many German Poles, the Treppa family attended St. Joseph's (German) church before a Polish parish was established. Martin and Anthony were on the committee to develop St. Albertus parish, also known in Polish as Parafia Sw. Wojciecha. The baptisms of Agnes and Ralph Treppa took place at St. Albertus church. The Treppa graves are in section M, lot 421.

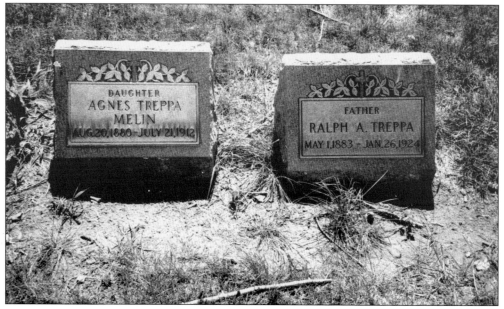

A Michigan historical marker denotes that Polish immigrants arrived in Detroit as early as the 1850s, but not until the Reverend Simon Wieczorek founded St. Albertus parish in 1872 did their community have a center. A neighborhood called Wojciechowo grew around the parish's first church. In 1885, the present Gothic Revival building replaced the original wooden frame structure. Although the community eventually dispersed, St. Albertus church still stands as a symbol of the first Polish community in Detroit. (SF.)

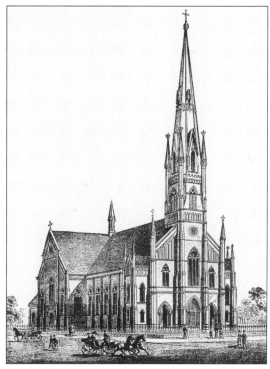

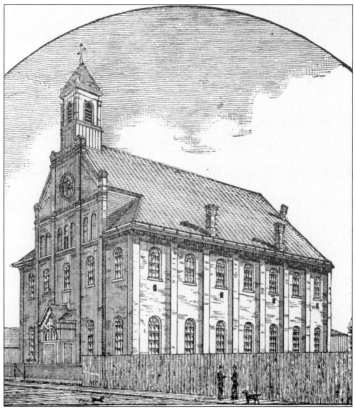

By 1878, a west side Polish settlement was organized. It extended from Twentieth to Twenty-third Streets. In 1882, this colony built a church on Twenty-third and Myrtle Streets by the name of St. Casimir. By 1890, the parish had grown so much that a new church was built, modeled after St. Peter's Basilica in Rome. This imposing edifice, long a west side Detroit landmark, was torn down in the early 1960s. (SF.)

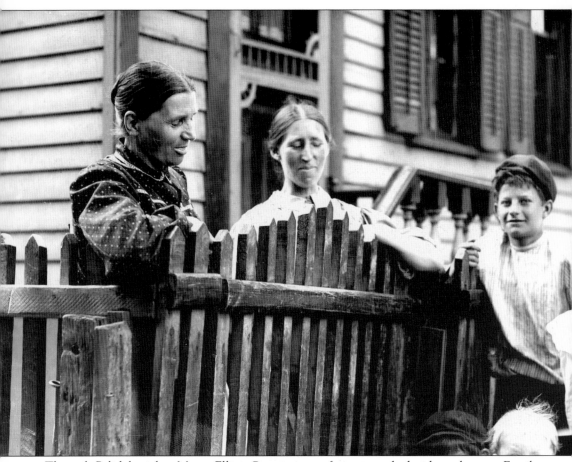

The early Polish burials at Mount Elliott Cemetery are often not marked with tombstones. Family historian Kathleen Labudie Szakall has three ancestral lines buried at Mount Elliott Cemetery: August Laga, Joseph Burkowski, and Mary Francisca Bielska. Pictured here are unidentified neighbors in the Polish community captured by a *Detroit News* photographer for the paper's ethnic collection. (DNC/WRL.)

Poles brought their village customs with them, such as the one pictured here, Dingus Day. This day follows Easter, and young people alternately switch and douse each other with water. Funeral customs brought to the United States included the practice of stopping the clock at the time of death. Floral arrangements at the wake often had a paper clock attached. Poles still observe Wszystkich Swietych and Dzien Zaduszny, October 31 and November 1, with family visits to cemeteries to clean and decorate family plots. (DNC/WRL.)

Polish families new to Detroit had to adapt to new burial practices. The parish practice in Poland was a term grave; the deceased would be buried in the church graveyard and the bones were exhumed after 25–35 years for a new burial. The style of grave markers used in Poland, such as wooden markers, wayside crosses, and wrought iron crosses, were not allowed at Mount Elliott Cemetery.

Dolores Dysarz Hausch has documented the history of the John Dysarz family. Johann (John) Dysarz left Wyschlin, Kreis Berent, West Prussia, to avoid conscription into the Prussian army. He arrived at Castle Garden on March 19, 1881, and married Emilia Grucza on May 7, 1883. Emilia was born in Centomie, Kreis Stargard, West Prussia, and had immigrated with her brother August. Together John and Emilia had 20 children, 7 of whom lived to adulthood. Their family lot is located in section H.

Sections S and P of the cemetery were reserved for single and pauper graves. Using James Tye's extractions, the names of the Poles buried in this area are known. Burials from 1866 to 1895 begin with Adamski, Adamowicz, and Anglewicz and end with Zablowski, Zardowski, and Zdziebko. The 1882 rules book mentions single graves and free graves. The family's pastor referred the case to the trustee from their parish.

Fr. Jozef Dabrowski (1842–1903) was the Polish community's Renaissance man. He established the Polish seminary and invited the Felician Sisters to the United States. Fr. Leopold Moczygemba was an advisor to Father Dabrowski and shared his dream of a Polish American seminary with the younger priest. Father Moczygemba was buried at Mount Elliott Cemetery but was moved to Panna Maria, Texas, in 1974, buried under the same live oak tree beneath which he had offered Christmas mass for the first Polish colonists in December 1854. (AFSLM.)

Mother Mary Monika Sybilska (1824–1911) was the first mother provincial of the Felician Sisters in America. The motherhouse in Detroit was established in 1881. This bas-relief of the pioneer sisters includes Mother Sybilska, Sr. Mary Cajatan Jankiewicz, Sr. Mary Wenceslaus Zubrzycka, Sr. Vincentine Kalwa, and Sr. Raphael Swozeniowska. Mother Sybilska is buried at Mount Elliott. (AFSLM.)

In 1895, the *Detroit Free Press* reported, "the object and scope of [Guardian Angels] was the maintenance of Polish orphans. A happy, well-disciplined company in their merry red frocks, the children played under the supervision of lay sisters under the grapevines. Either the Poles are a particularly hearty race and bear transplanting well or the little ones had been most carefully watched out for as there were no sick or ailing children to demand sympathy." Three sisters, Theresa, Cecilia, and Katherine Wojtkowiak, were half orphans and were entrusted with the Felician Sisters by their mother, when their father, Piotr (Peter), died in 1897. He was buried in a single grave at Mount Elliott Cemetery. When their mother, Marianna Adamska Wojtkowiak, wed Carl Henning in 1904, the girls were sent home. (AFSLM.)

Thomas Zoltowski was nicknamed "King of the Poles" because of his financial success as a brewer and his political influence. He donated one of the four bells of St. Albertus church that were used to ring the Angelus and toll for the dead. The bell weighed 2,000 pounds and was named for St. Thomas. It was blessed on June 5, 1885. Buried with Zoltowski and his wife Michealina are daughter Barbara and infants Hedwig, Victoria, and Joseph. The large cross stands in section N, lot 174. (DNC/WRL.)

Seven

RELIGIOUS ORDERS

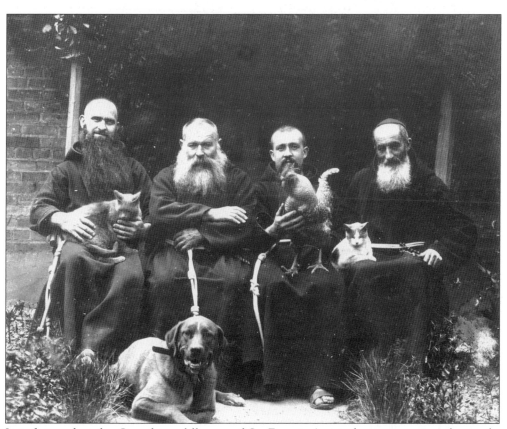

It is fitting that the Capuchins, followers of St. Francis Assisi, the patron saint of animals, should be photographed with a rooster, two cats, and a smiling dog. They are among religious orders that worked with the Catholic community in Detroit and provided the cornerstones of education, nursing, and orphan and spiritual care. Since 1883, they have been located across the street from the cemetery. (SBMA.)

From 1888 to 1918, Bishop John Samuel Foley (1833–1918) headed the Catholic Diocese of Detroit. As Detroit's first American bishop, his 30 years of leadership remains the longest for the Archdiocese of Detroit. Immigration to Detroit during this period was very heavy, not only from Europe, but also from the American South, to meet the labor needs of the automotive industry. Bishop Foley established the first black Catholic parish, St. Peter Claver, in 1911. He established a special seminary for the Poles and secured the religious ministrations of that nationality. A schism among them lasted several years and was healed through his forbearance. In 1907, the priests and laity of the diocese, in honor of the golden jubilee of his priesthood, presented Bishop Foley with St. Francis's Home for Orphan Boys, built at a cost of $250,000. Bishop Foley was first interred at Mount Elliott Cemetery, but was moved to Holy Sepulchre in Southfield, where the archdiocese maintains a bishop's burial area. (DNC/WRL.)

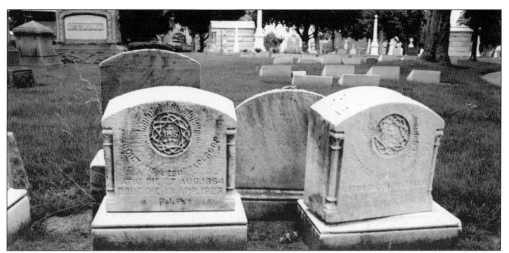

The Society of Jesus (commonly known as the Jesuits) is an international Catholic men's religious order composed of priests, brothers, and scholastics (men studying to be priests). They devote their lives to serving God through serving others. Members of the Society of Jesus work in high schools, universities, retreat houses, and parishes, as well as meeting other needs of people not just in America but also all over the world. In 1877, Casper H. Borgess, the bishop of Detroit, gave his cathedral, SS. Peter and Paul, to the Jesuits, provided they open a college in Detroit. Jesuits from St. Louis came to SS. Peter and Paul church and opened the Detroit College, now known as the University of Detroit. The University of Detroit was moved to McNichols Road in 1927. The University of Detroit High School was moved to Seven Mile Road in 1931.

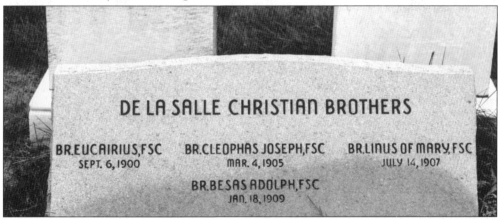

In 1851, Bishop Peter Paul Lefevre of Detroit invited the New York Province of Brothers to take charge of a school at Ste. Anne de Detroit. Four other schools were opened at St. Mary's, St. Peter's, Holy Trinity, and Cathedral parishes. All were closed in 1865, as a result of the depression that followed the Civil War. After a brief interval, the New York Province of Brothers were recalled to St. Mary's parish. In 1889, the New York Province of Brothers started St. Joseph's Commercial College. Then, in July 1944, they purchased the site from the archdiocese and renamed it St. Joseph's High School. In 1922, Bishop Michael Gallagher approved the New York Province of Brothers' new project to build an independent school—De La Salle Collegiate—and classes started in 1926. St. Joseph's High School was closed in 1963. In 1982, De La Salle Collegiate moved to Warren and is still in operation. In 1963, the St. Louis Province of the Brothers opened Bishop Gallagher High School in Harper Woods. It was closed in June 2005, although the New York Province of Brothers had departed in 1991.

The priests' lot has over 60 burials. Fr. John Foulon was from Belgium and died in 1845. Fr. John Farnan was buried in 1849. Rev. Francis X. Roth was buried in the 1850s. Fr. Julian Maciejewski was buried in 1869. Rev. James Hennessey and Brother Jacob were buried in the 1870s. More burials were recorded in the 1880s, including the Reverends Charles Chambille, Francis Bigelow, Michael Monahan, and Theophilis Anciaux. The 1890s burials included the Reverends John Lemke, Leopold Moczygemba, Cornelius Sullivan, and Basil Kuhn.

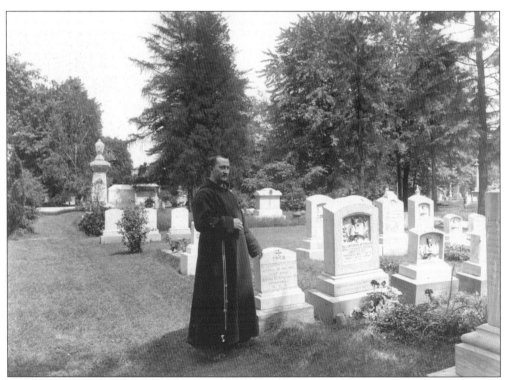

Fr. Crescentian Voelpel, Order of Friar Minor, Capuchin (OFM Cap), stands near the tombstones in the priests' lot (section E). Father Voelpel was the guardian of the monastery. The second tombstone from Father Voelpel is Fr. Anthony Svensson's tombstone. Father Svensson, who died in 1896, was the pastor of St. Elizabeth and was instrumental in establishing San Francesco as the first Italian parish in Detroit. He had studied in Rome, was familiar with Italian customs and culture, and could speak fluent Italian. (SBMA.)

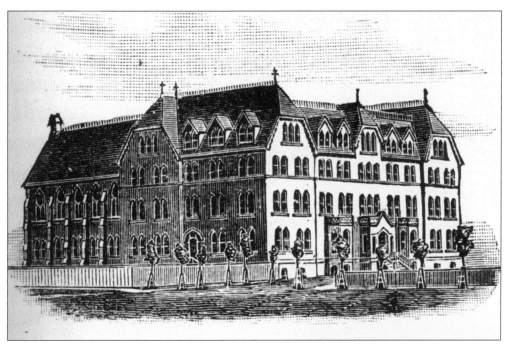

St. Vincent, in downtown Detroit, was established by the Daughters of Charity of St. Vincent de Paul. Two of the first four founding sisters are buried at Mount Elliott Cemetery. Loyola Richie, Sister Servant, led the mission in founding schools and the first hospital in Michigan. She built St. Mary's Hospital but died three months before it opened in 1850. Rebecca Delone suggested that the sisters open a hospital, and they raised funds for its replacement, the more substantial St. Mary's Hospital. She died in 1848 and is buried in grave 44 in section E. Lots 28–30 are dedicated to the Daughters of Charity of St. Vincent de Paul. In 1994, the Daughters of Charity of St. Vincent de Paul celebrated 150 years of service to Detroit. This celebration was marked with the publication of the book *Caritas Christi* and commutative service at Mount Elliott Cemetery. (SF.)

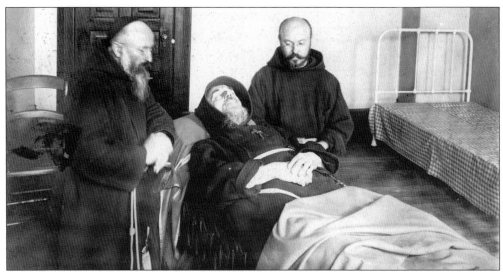

An unidentified friar is captured in repose. Thirteen friars were buried in section E at Mount Elliott Cemetery. The burials ranged from 1887 to 1943. The friars received permission in 1886 to build a crypt beneath the private chapel for the burial of deceased friars. Ten burial niches were planned, but none were ever used. The monastery received approval from the City of Detroit to establish a cemetery on its grounds and moved the remains to the Friars' Cemetery in September 1943. The following priests and friars were first interred at Mount Elliott Cemetery and now rest at the monastery's cemetery, which is pictured below: Fr. James Stuff (1887), Fr. Dominic Mersmann, Fr. Alphonse Baumle, Fr. Colomban Schaeffner, Fr. Timothy Grossmann, Fr. Gabriel Messmer, Fr. Ignatius Ullrich, Brother Luchesius Spruck, Brother Lucius Fuchs, Brother Thomas Faupel, Brother Fergus Kenny, Brother Seraphin Felsky, and Brother Julius Skupen. Brother Francis Spruck was the first friar buried directly in the Friars' Cemetery. (SBMA.)

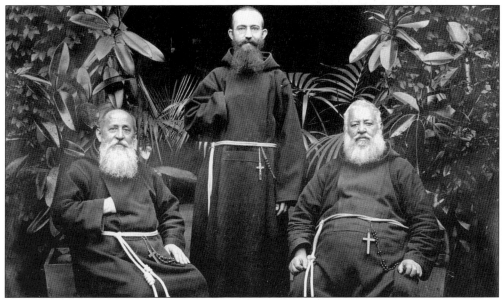

From the St. Bonaventure Monastery 1883–1993 anniversary book, *A Century of Prayer and Sharing*, pictured from left to right in the garden of the St. Bonaventure monastery are Capuchin friars Fr. Ignatius Ullrich (first guardian), an unidentified friar, and Fr. Jerome Henkel, the first vicar. Detroit's was the third monastery in the United States, selected because of its German population and its location midway between the monasteries in New York and Wisconsin. In 1883, Bishop Casper H. Borgess approved its establishment on Russell's Grove across from Mount Elliott Cemetery and granted the Capuchins permission to conduct graveside services. The monastery's chronicle recorded graveside services from 1884 to 1907. The Capuchins performed the service when the parish priest was not available or by the request of the family. In 1884, there were 117 funeral services conducted. By 1890, 418 services were recorded, and by 1899, the number grew to 569. From 1905 to 1918, the fathers provided the same service at Mount Olivet Cemetery. (SBMA.)

Sister Franciline, Patricia Van de Vyver, was born in Detroit on September 6, 1941, the oldest child of Hector Van de Vyver and Irene (Zygailo) Van de Vyver. She is best known in the Metro Detroit community for being the president of Madonna University for 25 years (1976–2001). She earned a bachelor's degree at Madonna University and both a master's degree and doctorate at Wayne State University. Her obituary published in the *Observer and Eccentric* newspaper said, "Leaders remember Sister Franciline. She was an angel wearing a habit." Sister Franciline is buried with her parents in section 119, lot 830. (AFSLM.)

Patricia Van de Vyver attended the Felician Academy and graduated in 1959. She joined the congregation a few weeks later. As a novice, she was given the name Sister Mary Franciline. She pronounced her final vows on August 7, 1967. The crown of thorns she wore that day was a constant companion in her room and was placed in her coffin for her viewing. She willed her crown to her youngest sister, who is also a Felician, Sister Joyce Marie. (AFSLM.)

The Felician Sisters were grateful for Fr. Jozef Dabrowski's guidance and wanted to honor him. They placed an order with Otto Schemansky and Sons on June 23, 1916, for a monument to mark Father Dabrowski's grave near the entrance of Mount Elliott Cemetery. This simple sketch belies the imposing cross that is in place, on a rustic pile of stones. On the lower stones are etched mementos from the Felician Sisters. The monument cost $11,000 in 1916 and is located in section A, lot 167. (BN.)

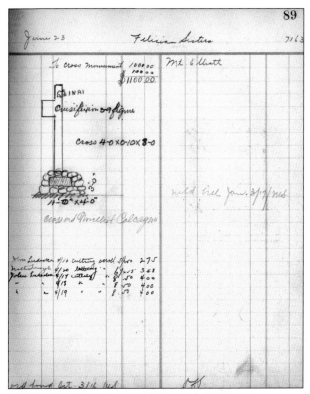

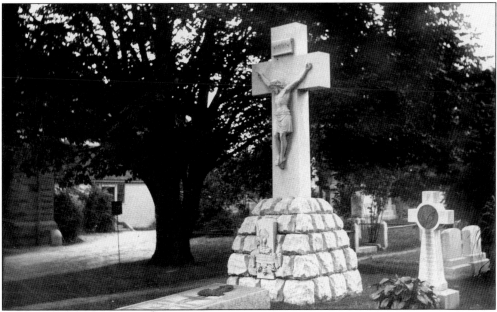

Sr. Franciline Van de Vyver wrote, "The early awakenings of my vocation were heard in the stillness of Mount Elliott Cemetery, when, as a little girl going to work with my father on Saturdays, I looked upon the grave of Fr. Joseph Dabrowski [pictured here] and wondered who he was. Now let me tell you something about being a nun for 42 years. That is all I ever wanted to be!" (AFSLM.)

Mother Mary Monika Sybilska (1824–1911) was the first mother provincial of the Felician Sisters in America. Fr. Jozef Dabrowski advised them to travel in secular clothing when they entered Prussia, because of Bismarck's religious intolerance. The motherhouse in Detroit was established in 1881. (AFSLM.)

The Felician Sisters make a pilgrimage to the burial site of their founders. Under Father Dombrowski's direction, his order founded the American branch of Felician Sisters and operated many elementary and high schools in Detroit, as well as Madonna University in Livonia and the Guardian Angel Home, an orphanage in Detroit. Pictured here is the grave site of Mother Sybilska in section 120, lot 835. (AFSLM.)

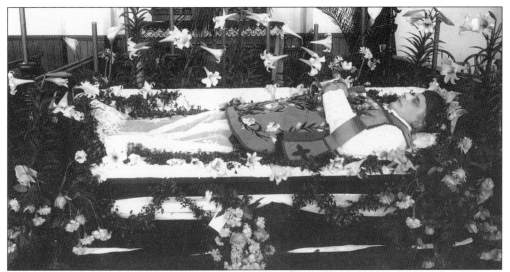

The *Detroit Free Press* reported on the Fr. Jozef Dabrowski viewing. The page 1 story read, "The remains of Rev. Jozef Dabrowski lay in state at St. Albertus Church last night and were viewed by thousands of the deceased's countrymen. The church was draped in mourning and the bier was heaped with floral offerings. Members of various societies connected with the church knelt on prayer before the body of their benefactor." (AFSLM.)

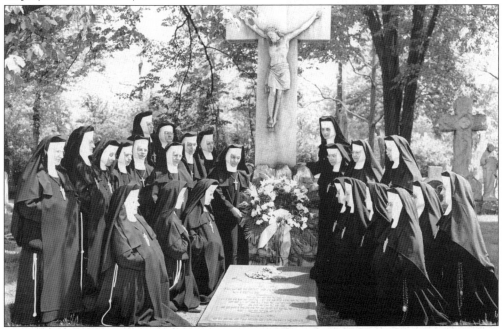

Father Dabrowski (born January 19, 1842; died February 15, 1903; buried in section A, lot 167) was the founder of SS. Cyril and Methodius Roman Catholic Seminary (1885–1903). He came to the United States in 1869, serving as a priest in Wisconsin, and later Detroit. Recognizing the need for priests who understood the Polish language and customs, he sought permission to establish a seminary for Polish-speaking priests. In 1885, he set up his seminary at Forest and St. Aubin Streets in Detroit. It moved to Orchard Lake in 1909. He later established St. Mary's College and High School. (AFSLM.)

KS. WITOLD
BUHACZKOWSKI
Umarł
10-go Sierpnia, 1925.
Licząc lat 63.

The Orchard Lake School's Web site chronicles the life of Fr. Witold Buhaczkowski (1903–1916) who was a rector at the Polish seminary in Detroit. The academic framework of the seminary took shape over a few years, after its formal founding in 1885. By the 20th century, the seminary evolved into three divisions, indispensable to one another: the classical training in the high school, a two-year philosophy program leading to lay professions in law, medicine, and the like, and a four-year theology program for the preparation of priests. Increasingly the schools found themselves juggling crowded neighborhoods and the pressure of 300 boarding and day students and 20 resident faculty members. The solution came in a bold stroke, with the purchase of the grounds and buildings of the former Michigan Military Academy and the move to the beautiful lakeside property, 25 miles northwest of Detroit in July 1909. Father Buhaczkowski is buried next to Father Dabrowski in section A, lot 167.

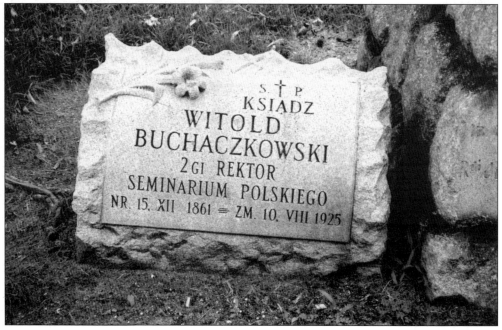

The School Sisters of Notre Dame in the Milwaukee Province includes all of Wisconsin, Michigan, and Indiana. The congregation of the School Sisters of Notre Dame was created to address educational needs. In 1847, Mother Theresa brought her sisters to the United States to meet the educational needs of the children of German immigrants. On September 11, 1911, the School Sisters of Notre Dame opened the San Francesco school in a rented space. In 1923, they moved into a modern building. The school closed in 1952. This monument is located in section E.

Buried in the priests' lot in section E, Fr. Christian Denissen was born in Rozendaal, Holland, and came to the Detroit area around 1872. Pastor of St. Charles church, Father Denissen is known for his research on French families in the Detroit River area. He shared an interest in history and genealogy with his friend Clarence Burton. Father Denissen willed his 20,000 pages of manuscript—spanning from 1701 to 1911—to Burton. The Detroit Society of Research published *Genealogy of the French Families of the Detroit River Region* for the bicentennial in 1976. It was revised in 1987.

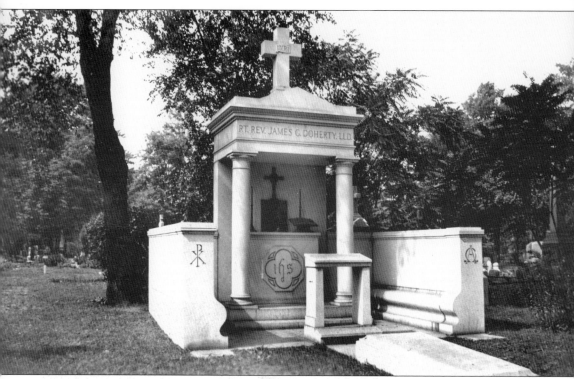

The Right Reverend James G. Doherty (born February 13, 1847; died February 18, 1926; and buried in section B, lot 5) came to Detroit's SS. Peter and Paul church in 1876. Soon afterward, he was sent to Osceola and Howell, where he remained for 10 years, building the church for those towns. In July 1886, he joined St. Vincent de Paul, taking great pride in the beauty of the lawns there. He also established the young men's hall. In his will, Reverend Doherty left $12,000 for a memorial to be built at Mount Elliott Cemetery in his name. The granite memorial, designed by Otto Schemansky and Sons, represents the sanctuary of a church. The canopy over the altar is Roman style. The altar is set for low mass, and the symbols are bronze. Most of Reverend Doherty's remaining estate, worth more than $1 million, was left to charity.

Eight

MILITARY

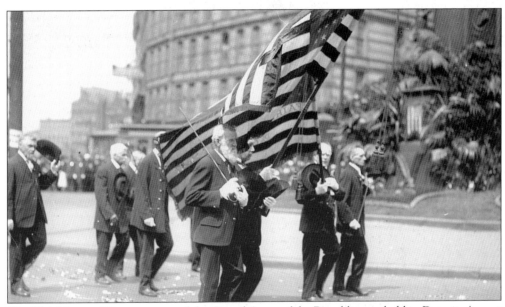

The 25th National Encampment of the Grand Army of the Republic was held in Detroit, August 5–7, 1891. The Grand Army of the Republic, often referred to as the GAR, was founded at Decatur, Illinois, on April 6, 1866. The online site of the GAR Museum and Library gives the following history: "Dr. Benjamin Franklin Stephenson founded the organization on the three cardinal principles of fraternity, charity, and loyalty. To become a member of the GAR, a man must have served in the United States Army, Navy, Marine Corps, or Revenue Cutter Service (today's United States Coast Guard) between April 9, 1861, and April 12, 1865. He also must have been honorably discharged from the service and have never taken up arms against the United States of America. These men, who had lived together, fought together, foraged together, and survived together, had developed unique bond that could not be broken. As time went by, the memories of the filthy and vile environment of camp life began to be remembered less harshly and, eventually, fondly. Friendships forged in battle survived the separation. By 1890, the GAR numbered 409,489 veterans of the Civil War." (DNC/WRL.)

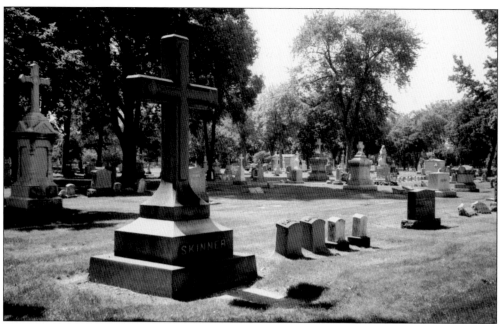

The Skinners, descendants of John Whipple, placed a ledger in his honor. The family is buried in section T, lot 78. Maj. John Whipple "was an officer during the war of 1812 and served under Mad Anthony Wayne. During the war, John Whipple was hunted by British authorities who suspected he was in Detroit. For 13 months during the British occupation of the city, John Whipple lived in the cellar of the family's home." The Michigan Supreme Court Historical Society's biography of Judge Charles Whipple continues with: "Charles' mother cautioned him to keep his father's whereabouts a secret or their lives would be in jeopardy." The shadow of the cross marks the ledger commemorating Maj. John Whipple. He is buried in Memorial Place cemetery, Monroe, Monroe County.

Col. John Francis Hamtramck, who was buried for a time in section 71, lot 507, was originally buried in the graveyard of Ste. Anne de Detroit, but in July 1866, the remains were removed, placed in an oaken casket, and reinterred in Mount Elliott Cemetery. His grave in Mount Elliott Cemetery was located at the intersection of Shawe and Resurrection Avenues. He was one of the last interments at Ste. Anne de Detroit's cemetery before the fire of 1805. Hamtramck had joined the American army during the Revolutionary War and in February 1793 served under Anthony Wayne in the Northwest. As commander of Detroit during the American occupation, he won the affection and respect of the city. Hamtramck died on April 21, 1803, at about 48 years of age. His remains were moved again to Memorial Park, in Hamtramck, Michigan, on May 26, 1962.

Colonel John Francis Hamtramck
1758-1803

ONE HUNDRED FIFTY YEARS AGO on July 11, 1796, COLONEL JOHN FRANCIS HAMTRAMCK, a valiant soldier of the Revolutionary War and a confidante of GENERAL GEORGE WASHINGTON, received the surrender of the British Garrison at Detroit and raised the American Flag for the first time over Fort Lernoult, signalizing the beginning of American occupation here.

COLONEL HAMTRAMCK was a warm personal friend of GENERAL ANTHONY WAYNE, and his comrade in the field. Following the occupation, Hamtramck decided to remain here. He built his home on the shore of the Detroit River some distance beyond the present approach to the Belle Isle Bridge. Here he died and he was buried in the cemetery of old Ste. Anne's Church. Later his remains were placed in the Mt. Elliott Cemetery, where he rests today.

MEMORIAL DAY 1946

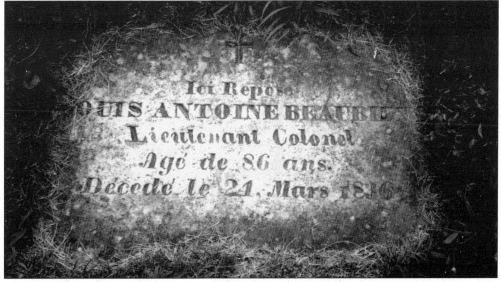

Lt. Col. Louis Antoine Beaubien was born around 1750 and died March 24, 1836. He is buried in section 103, lot 702. He was known as Antoine, the son of Jean B. Beaubien. The Beaubiens settled in Detroit around 1730. Their farm consisted of 337 acres, bound on the west by the Brush farm, on the east by the Moran farm, and extended north three miles from the Detroit River. In 1835, Beaubien Street was named after his brother Lambert Beaubien, landowner and veteran of the War of 1812. When Lt. Col. Beaubien died his body was laid to rest in the crypt under Ste. Anne de Detroit, beside Father Richard. When Ste. Anne de Detroit was demolished, Lt. Col. Beaubien's remains were moved to Mount Elliott Cemetery. The farm was left to his sons Antoine and Lambert.

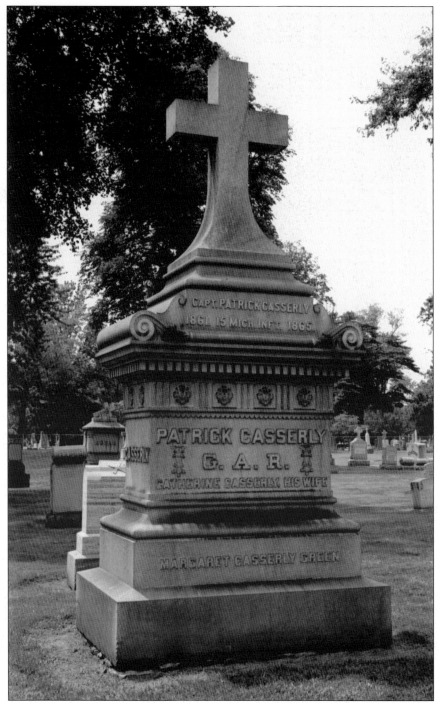

Patrick Casserly enlisted in Company F, 15th Infantry on November 1, 1861, at Detroit for three years, when he was 30 years of age. He was a first sergeant, mustered on January 29, 1862, and he was commissioned as a first lieutenant on July 6, 1863. He was wounded on July 28, 1864, at Atlanta, Georgia. He was discharged on December 24, 1864, because of the wounds. This stunning monument is in section I, lot 323.

This is the 25th GAR National Encampment in Detroit, in 1891. The encampment was presided over by the elected commander, senior and junior vice commanders, and the council. Encampments were multi-day events that often included camping out, formal dinners, and memorial events. The Sons of Union Veterans of the Civil War also state that GAR called for setting aside May 30, 1868, for remembering fallen comrades—the first Memorial Day.

Capt. William R. Elliott (born August 13, 1836) died July 5, 1863, in the Civil War's Battle of Gettysburg. He was the son of Judge Robert T. Elliott, for whom Mount Elliott Cemetery was named and is buried in section 71, lot 506.

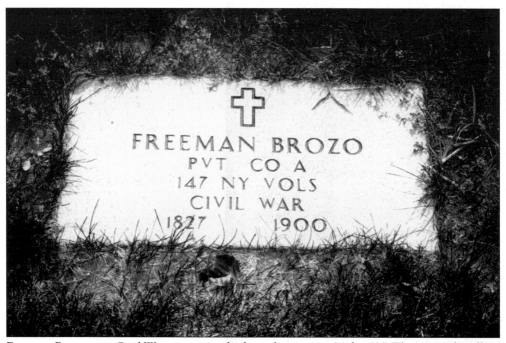

Freeman Brozo was a Civil War veteran and is buried in section 94, lot 639. The original spelling of his name was Pierre Firmin Brazeau. Also buried here are Freeman's wife Elizabeth Germain Brozo and David Wayne Brozo, his great-grandson.

Maj. Robert T. Elliott (born September 23, 1830) was a member of the Detroit Light Guard. He died May 30, 1864, in Virginia while in command of the 16th Michigan Infantry during the Civil War. He was the son of Judge Robert T. Elliott, for whom Mount Elliott Cemetery was named, and is buried in section 71, lot 506. (AM.)

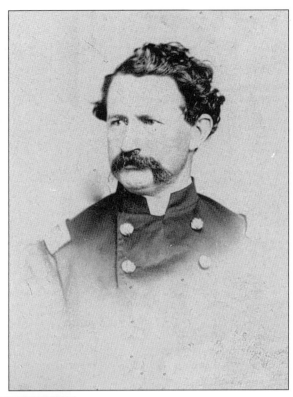

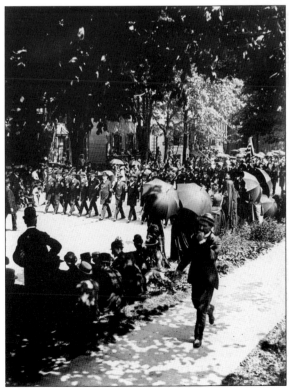

As seen here in this *Detroit News* photograph, the GAR members parade as an elaborate multiday event that often included campouts, formal dinners, and memorial events. (DNC/WRL.)

Charles Gaffney Sr. (born around 1844; died May 8, 1922; and buried in section Q, lot 9) served in the Civil War with the 24th Regiment, the Iron Brigade, and took part in the heavy fighting around Gettysburg. His brothers were William and Charles. His son Frank Gaffney (born 1867; died February 17, 1936; and buried in section Q, lot 9) was a real estate dealer.

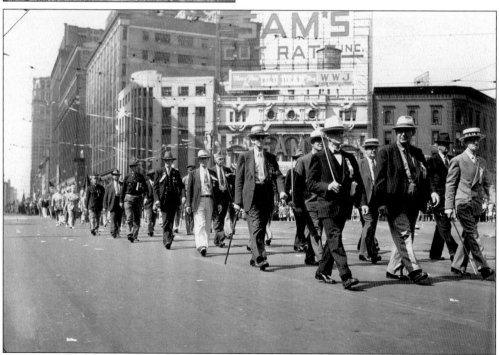

Spanish-American War veterans march in this photograph from the *Detroit News*, August 21, 1940. (DNC/WRL.)

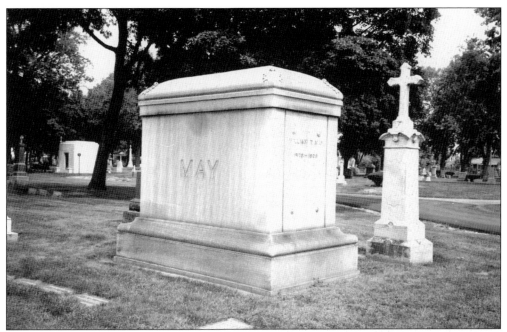

William T. May (born 1879; died October 28, 1908; and buried in section Q, lot 4), served in the Spanish-American War as a volunteer. In 1905, he married Jessica Ranger of New York. He was president of Detroit Bath Tub and Brass Manufacturing Company. His brothers were Thomas G., Peter D., and Alfred L.

Maj. John Considine Jr. was born December 19, 1862, and died on January 15, 1931. He is buried in section D, lot 6, with the inscription "Spanish American War Veteran."

On July 4, 1919, Detroit mayor Frank Couzens headed a welcoming committee that met 1,500 men in New York Harbor and escorted them home where an enormous welcoming ceremony and party were held on Belle Isle. Michigan voted to give all of its soldiers and sailors a cash bonus of $15 for each month served under the flag. (DNC/WRL.)

In the late 1920s, the War Department of the United States compiled a list of mothers and widows of deceased soldiers killed in World War I and offered to send them to their loved one's final resting place in Europe. Each record provides the name of widow or mother, city and state of residence, and relationship to the deceased. Information regarding the deceased's name, rank, unit, and cemetery is provided. Providing information regarding nearly 11,000 mothers and widows, this database can be useful for family history researchers seeking World War I veterans. The circular medallion next to Celia Licht's headstone identifies her as an American War Widow. The Lichts are buried in section 36, lot 284.

This World War II prayer card was designed by the St. Anthony Guild in 1941. It was usually distributed with the following "Prayer for Our Soldiers or Sailors" on the back: "Oh Divine Jesus, we beseech You to protect who are faced with the dangers of war. Pour forth Your grace into the hearts and souls of our soldiers, that they may lead their lives in conformity to your holy will."

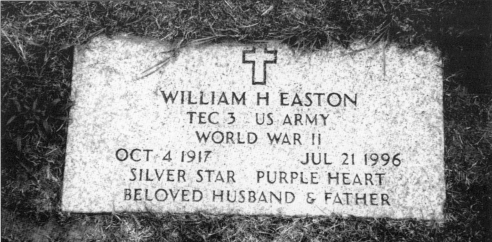

William H. Easton (1917–1996), buried in section D, lot 73, is also listed on the National World War II Memorial Web site by his sister, Hester E. Abbott. Families of other World War II veterans can also place their veteran's name. The memory of America's World War II generation is preserved within the physical memorial and through the World War II Registry of Remembrances, an individual listing of Americans who contributed to the war effort. Any United States citizen who helped win the war, whether a veteran or someone on the home front, is eligible for the registry. The Department of Veterans Affairs furnishes upon request, at no charge to the applicant, a government headstone or marker for the grave of any deceased eligible veteran in any cemetery around the world.

The National Parks Service offers this history of the monument: "The Michigan Soldiers' and Sailors' Monument is the state's foremost Civil War monument. This outstanding example of civic sculpture stands in a prominent downtown location on the southeast tip of Campus Martius, where five principle thoroughfares intersect—Michigan Avenue, Monroe Street, Cadillac Square, Fort Street, and Woodward Avenue. In 1865, the Michigan Soldiers' and Sailors' Monument Association was established by Gov. Austin Blair to collect funds for a monument commemorating Michigan's sailors and soldiers killed during the Civil War. Voluntary subscriptions from citizens were collected, and sculptor Randolph Rogers, who had created similar Civil War commemorative monuments in Ohio and Rhode Island, was chosen as the artist for the monument. Rogers's design consists of a series of octagonal sections that rise up from the base of the monument. The lowest sections are topped by eagles with raised wings that guide the eye upward to the next section that is surmounted by four male figures depicting the navy, infantry, calvary, and artillery branches of the United States Army." (SF.)

114

Nine

THE LAST ALARM

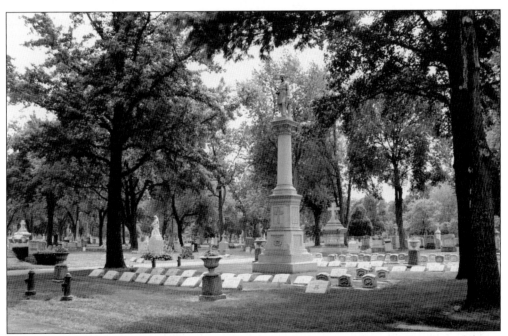

The Firemen's Fund was developed to provide pensions for widows and burials for the firefighters. On July 5, 1889, the Firemen's Fund erected a monument on the Mount Elliott Cemetery plot, and it was similar to the one designed by Charles Marsh at Elmwood Cemetery. The Michigan Granite Company of Adrian completed the Mount Elliott Firemen's Fund monument in February 1890, at a cost of $2,965. Today Memorial Day services are held annually by the Detroit Firefighters Association; on even-numbered years, they are held in the Mount Elliott plot, and on odd-numbered years, they are held at Elmwood Cemetery. Any active or retired firefighter who is a member of the Firemen's Fund may be buried in one of these plots. The only costs involved are the opening and closing of the grave.

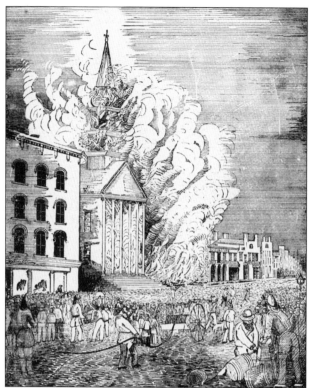

On January 10, 1854, the First Presbyterian Church on Woodward Avenue and Larnard Street burned, along with many shops. Silas Farmer wrote, "The burning of the church was a sad but splendid sight; as the flames streamed up and enveloped the steeple, they illuminated half the city." This etching was adapted from a painting by Robert Hopkin created on the morning of the fire. (SF.)

This illustration appears on the membership certificate of the Firemen's Fund. It is modeled after the *Detroit News* photograph that documented the fire department's horses making their last run down Woodward Avenue. On April 10, 1922, more than 50,000 people turned out to witness it. The city's last five fire horses, Pete, Jim, Tom, Babe, and Rusty, made their final dash. Spectators lined the streets and cheered as the fire department's band played "Auld Lang Syne." (DFFA.)

In 1805, most of Detroit was destroyed in an accidental fire. The seal of Detroit depicts the city as two women—one is the past and the other is the hope for the future. Behind the latter, on the right, is a picture of Detroit's rebuilding. The Latin inscription above the women reads *Speramus Meliora*—"We hope for better things." The Latin below reads, *Resurget Cineribus*—"It shall rise again from the ashes." (DNC/WRL.)

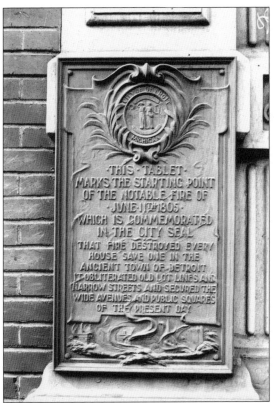

The area set aside for the firemen's burials is marked by antique fire hydrants and marble tablets that have the name of the association engraved on them. There are two sets of hydrants and markers, one set to the left of the monument and one set in front of it. The tablets are characteristic of funeral signage from an earlier era. Ground signs such as these are no longer permitted.

This is a close-up of the symbol of the Firemen's Fund that is carved on the monument. It represents the flames of fire and the hoses used to extinguish them. This design is seen on the tombstones of the firefighters buried around the monument. The leather helmet has a speaking trumpet behind it.

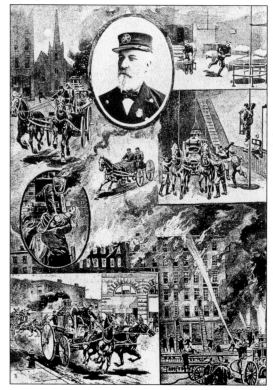

This illustration is from the book *Our Firemen*. The book is described as "a record of the faithful and heroic men who guard the property and lives of the city of Detroit, and a review of the past, giving the history of the Fire department since the early settlement of the city, with a glance at our city of to-day edited by Charles S. Hathaway." It was issued for the benefit of the Firemen's Fund Association and published by J. F. Eby in 1894. (WSULS.)

John Miller (died August 17, 1867, and was buried in section D, lot 58) was the first active member of the Firemen's Fund who was fatally injured on the job. He was a pipeman with Engine No. 3 who fell from a ladder. The Firemen's Fund provided benefits to firemen who died in the line of duty. His family was given $100 for the cost of the funeral. The $30 cemetery plot and headstone also were provided by the fund.

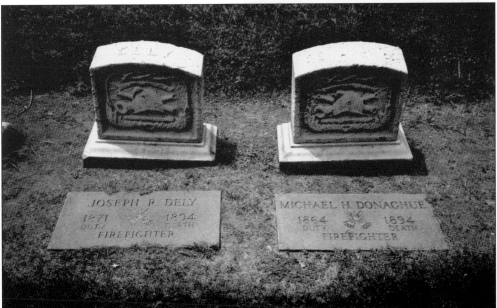

Joseph Dely (1871–1894) and Michael Donaghue (1864–1894) both died on October 5, 1894, on duty along with Martin Ball, John Pagel, Julius Cummings, and Fred Busset; they were all killed by a falling wall. The fire was at the Keenen and Jahn Warehouse at 213–217 Woodward Avenue near Grand River Avenue. The loss of property was $82,000. Dely was born in Michigan, the son of shoemaker Joseph Dely and Susan Dely.

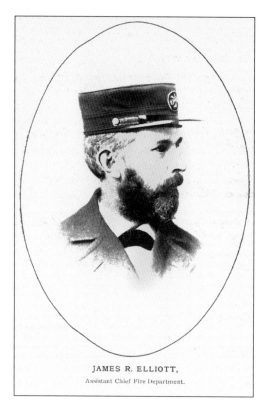

JAMES R. ELLIOTT,
Assistant Chief Fire Department.

James Battle, born in County Sligo, Ireland, came to the United States as an infant. He was the first paid fire chief of the city of Detroit, and his career spanned from 1852 to 1895. He was succeeded by James R. Elliott (1834–1898), who led the funeral for Battle. The funeral was chronicled in the *Detroit News*: "Engine companies, truck companies and Chemical No. 4 pooled their money to erect a 'heavenly portal' a perspective floral arrangement made of five Gothic arches. It was arranged inside SS. Peter and Paul Church and the front and largest portal was nine feet tall and was surmounted by a cross in green and white and a white dove. Over 2,000 roses were used and barrels of carnations, sweet alyssum, lilies of the valley and other flowers. Across the summit of the larger arch was the inscription 'Our Chief' wrought in purple flowers." (WSULS.)

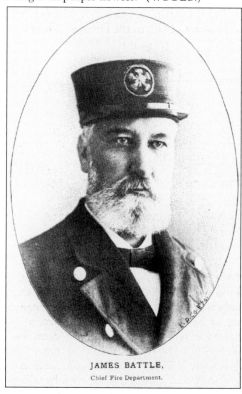

JAMES BATTLE,
Chief Fire Department.

Form 6. B. of H. Office in Central Market Building.

Certificate of Death.

No.

FOR THE MONTH OF _____ **IN THE CITY OF DETROIT, MICH.**

Physicians are required by the Board of Health to fill out this Certificate accurately, and deliver to the Health Office, within twenty-four hours after death of the person to whom it relates. MAXIMUM PENALTY for neglect of so doing, $500.

1. Name _Patrick Coughlin_ Color _White_
2. Sex _Male_ Married _Yes_ Single _____
3. Age _34 years_
4. Name of Father of Deceased _Michael Coughlin_ Nativity _Ireland_
5. Name of Mother of Deceased _Margaret_ " Nativity "
6. Occupation of Deceased _Fireman_
7. Place of Birth of Deceased (Town, County, State) _Detroit Mich_
8. Name of Wife of Deceased _Catherine Coughlin_
9. Name of Husband of Deceased _____
10. Date of Birth _____ Date of Death _Dec 3 1890_
11. Cause of Death _Fracture of Skull_
12. Duration of Disease _____
13. Place of Death _Harper Hospital_ Street _____ 1 Ward.
14. Place of Burial _Mt Elliott_
15. Undertaker _P Blake & Sons_

Residence of Physician _____

Detroit _____ 189_ _Richard Forney Cor_ M.D., Attending Physician.

Burial Permit No. _36827_ Date _____ 189_ To be buried _Dec 6_ 1890

No Burial Permit will be issued upon this Certificate unless correctly filled out, signed and returned by the attending Physician or Coroner.

This is the December 3, 1890, death certificate for Patrick Coughlin, who died in the Scotten Dillon fire. The cause of death was a fractured skull. Born in Detroit, he was 34 years old when he died at Harper Hospital. His father, Michael, and mother, Margaret, were born in Ireland. His wife, Catherine, made arrangements with Patrick Blake for the burial. He was buried on December 6, 1890, in the Firemen's Fund lot. (DFFA.)

DETROIT FIRE DEPARTMENT.

APPLICATION FOR PENSION.

To the Honorable the Board of Fire Commissioners of the City of Detroit.

Catherine (Kate) Coughlin filed an application for pension with the Firemen's Fund. It states that her husband, Patrick Coughlin, was a lieutenant with Engine No. 8. Kate stated that they were married on November 6, 1883, and had two children, Raymond Michael born January 23, 1886, and Edwin, born November 4, 1887. Among the paperwork was a certificate that stated he was injured by falling walls, and died about two hours later. (DFFA.)

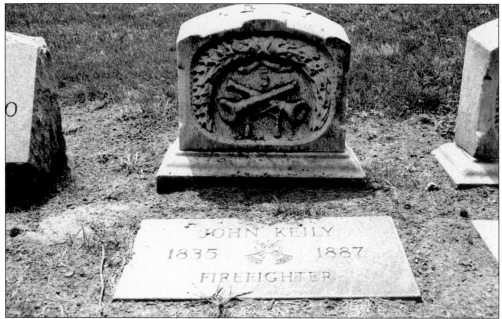

John Keily's (1835–1887) tombstone carries on the Irish tradition of listing the county of birth. He was born in Carlow, County Carlow. His tombstone has a laurel wreath, a symbol of eternity, that surrounds crossed trumpets. Paul Hashagen of Firefighter Central explains the symbolism: the trumpets are important symbols for firefighters; the officers called cadence through the trumpets to keep the men on the hand pumpers on time in the noisy environment, and chief officers used them for overall command at the scene of working fires. They also became part of the elaborate uniforms of the volunteer firemen. The trumpet has carried on to this day as an insignia of rank in most departments—one trumpet for a lieutenant, two for a captain, and crossed gold trumpets, up to five in number, to signify the chief of department.

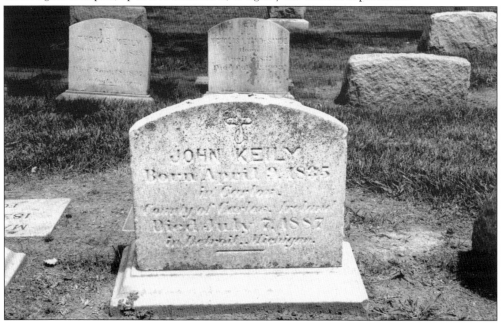

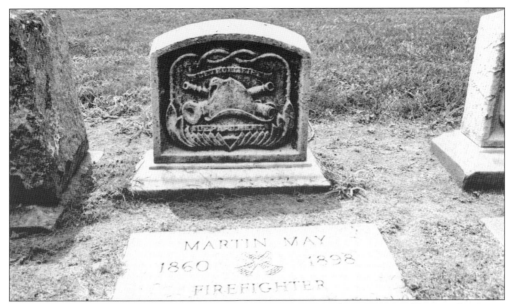

Martin May was born in 1860 and died on June 5, 1898. He was the pipeman of Engine Company No. 1. The tombstone has the Firemen's Fund insignia on the front and an inscription on the back. Many of the older stones have weathered, so the Firemen's Fund has added new stones to make sure the names are legible. The helmet portrayed here seems to have the Cairns and Brothers eagle holding the shield. In the June 14, 1930, *New Yorker* the Cairns and Brothers Company is explained: "The firemen's helmets were made of stout, tanned western cowhide, a quarter of an inch thick, hand-sewed, reinforced with leather strips that rise like Gothic arches inside the crown, and padded with felt. The long duckbill effect, or beavertail, that protrudes from the rear is to keep water from running down firemen's necks. Hats for battalion chiefs and higher officers were white, and all others are black. They sold for $8.75 in 1930. The handcrafted helmets lasted about 10 years."

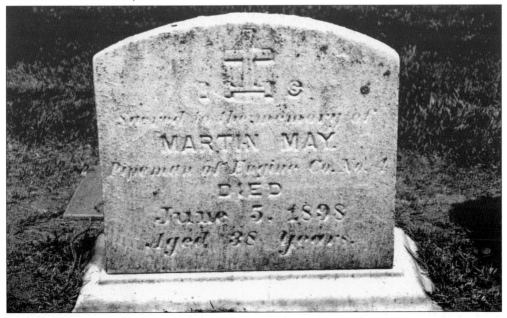

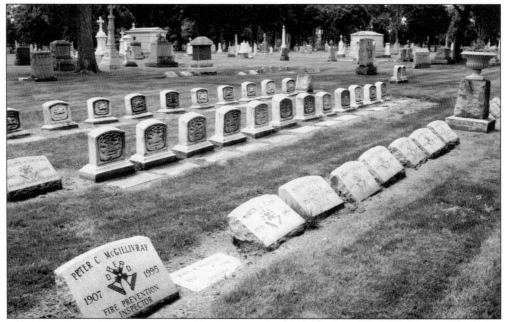

These graves represent some of the firefighters' burials at Mount Elliott Cemetery. They are honored by an annual Memorial Day tribute that alternates between Mount Elliott Cemetery and Elmwood Cemetery. The parade begins at the firehouse on Lafayette Street and Mount Elliott Avenue and proceeds to the firemen's lot. A bell is rung in remembrance of all firefighters who have died over the past year, and a floral tribute is given to their families.

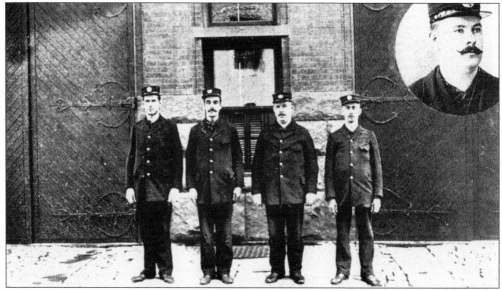

The Chemical Company No. 1 firefighters seen here include Lt. M. H. Dougahue (inset), who was killed on October 5, 1894, by falling walls. The Firemen's Fund published *Our Firemen* in 1894, with the explicit purpose of showing the city fire engine companies as important social organizations. The book says, "Every member of the department is a specialist, whose skill and courage is backed by an absolute singleness of purpose—the protection of lives and property for the citizens, who are their employers." (WSULS.)

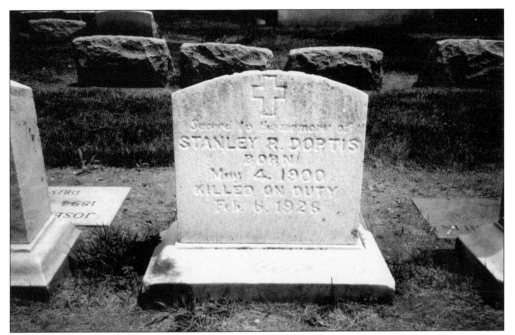

Stanley Doptis (1900–1926) was killed in duty on February 6, 1926. He was a pipeman and was assigned to station 1. He died in an accident between a firemen's rig and a streetcar. In 1920, there were only 17 people in the city of Detroit named Doptis. His mother may have been Sophie, listed as a widow.

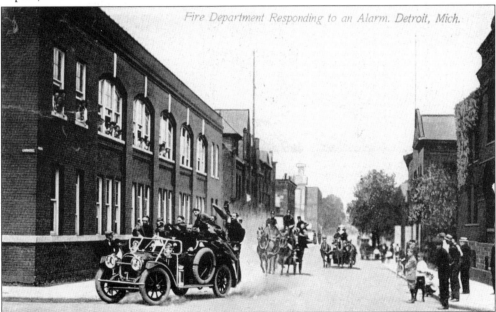

The back of this postcard reads, "The Detroit Fire Department is acknowledged the best conducted department in the country. This view shows the company responding to an alarm with their new 30 H.P. Packard squad wagon in the lead. This machine has a speed of 75 miles an hour and carries 12 men." The card, postmarked March 1912, was sent by Lawrence Lemke to his sister Ella Lemke in Alpena.

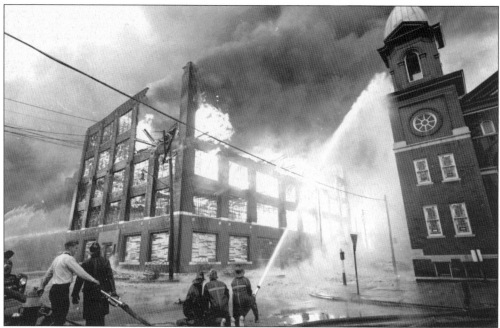

The fire on April 10, 1963, at the old Briggs Plant at 3100 Meldrum Street also destroyed Our Lady of Sorrows Catholic church. The fire broke out in the old factory across from the church while the congregation was attending morning mass. They escaped unharmed, but several parishioners' cars were lost to the fire. The Detroit Fire Department had to fight both fires. The firemen rescued the cross from the church, and the lead fireman in the photograph below can be seen carrying out the arms of the figure of Christ. The parish raised funds for a new church, and it was dedicated on May 16, 1967. It was a moving experience, as the same firemen who rescued the large crucifix from the fire were able to carry it back into the new church. (Above, DNC/WRL; below, GSFA.)

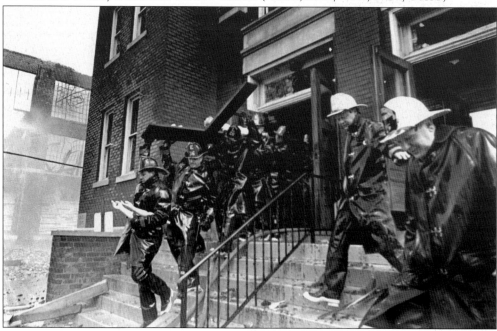

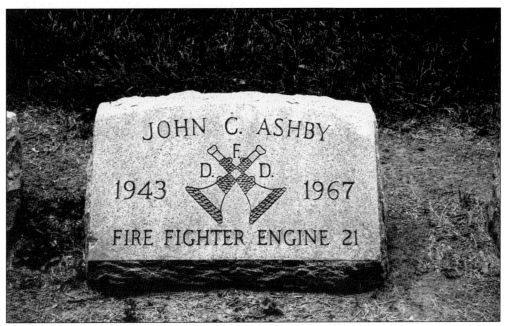

Firefighter John C. Ashby was born in 1943 and died on August 4, 1967, from injuries sustained during the Detroit riots. Ashby served with the Detroit Fire Department, Engine No. 21. He was electrocuted by a high-tension wire that struck his helmet while fighting a fire at a supermarket on Lafayette Street and Canton Street on Detroit's East Side. He died a few weeks later at Detroit General Hospital. Fireman Carl Smith was killed by a gunshot wound during the riots.

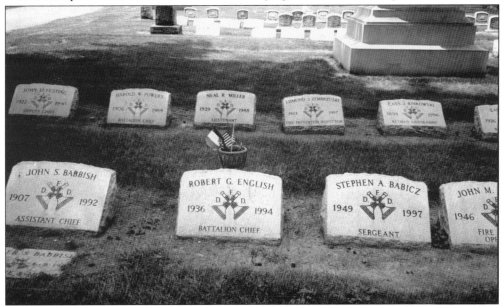

Robert Gerald English's grave is graced by the flags of the United States and Ireland. English was born on September 19, 1936, and died February 5, 1994. He lived in Redford and died in Detroit. He is buried with his peers in front of the Firemen's Fund monument. The tombstones pictured here include John E. Fusting (1922–1990), Howard W. Powers (1906–1988), Neil R. Miller (1939–1988), Edmund J. Ziembruski, Cass J. Binkowski, John S. Babbish, and Steven A. Babicz.

ACROSS AMERICA, PEOPLE ARE DISCOVERING SOMETHING WONDERFUL. *THEIR HERITAGE.*

Arcadia Publishing is the leading local history publisher in the United States. With more than 3,000 titles in print and hundreds of new titles released every year, Arcadia has extensive specialized experience chronicling the history of communities and celebrating America's hidden stories, bringing to life the people, places, and events from the past. To discover the history of other communities across the nation, please visit:

www.arcadiapublishing.com

Customized search tools allow you to find regional history books about the town where you grew up, the cities where your friends and family live, the town where your parents met, or even that retirement spot you've been dreaming about.